STUDY
with
ME

STUDY *with* ME

EFFECTIVE BULLET JOURNALING
TECHNIQUES, HABITS, AND HACKS
TO BE SUCCESSFUL, PRODUCTIVE,
AND ORGANIZED

JASMINE SHAO
of @studyquill

ALYSSA JAGAN
of @craftyslimecreator

QUARRY

Brimming with creative inspiration, how-to projects, and useful information to enrich your everyday life, Quarto Knows is a favorite destination for those pursuing their interests and passions. Visit our site and dig deeper with our books into your area of interest: Quarto Creates, Quarto Cooks, Quarto Homes, Quarto Lives, Quarto Drives, Quarto Explores, Quarto Gifts, or Quarto Kids.

First Published in 2019 by Quarry Books, an imprint of The Quarto Group, 100 Cummings Center, Suite 265-D, Beverly, MA 01915, USA.
T (978) 282-9590 F (978) 283-2742 QuartoKnows.com

Quarry Books titles are also available at discount for retail, wholesale, promotional, and bulk purchase. For details, contact the Special Sales Manager by email at specialsales@quarto.com or by mail at The Quarto Group, Attn: Special Sales Manager, 100 Cummings Center, Suite 265-D, Beverly, MA 01915, USA.

10 9 8 7 6 5 4 3 2 1

ISBN: 978-1-63159-778-7

Digital edition published in 2019
eISBN: 978-1-63159-779-4

Library of Congress Cataloging-in-Publication Data available

Design: Debbie Berne
Page Layout: Sporto
Photography: All photos by Jasmine Shao or Alyssa Jagan; except page 107, Cierra Jagan, and page 111, Amanda De Matos

Printed in China

DEDICATION

Whether you've been
subscribed since day one or
just watched two seconds of a video
last Monday, this one's for you.

Jasmine

To all my teachers
and mentors, especially
Ms. Welbourn.

Alyssa

TABLE OF CONTENTS

PREFACE BY JASMINE SHAO

I have no clue why I started my YouTube channel. One crisp autumn afternoon in my freshman year of high school, I thought that maybe filming a "what's in my pencil case" video would be fun. My memory escapes me; I can't recall the original reason for my topic of choice. Looking back as a soon-to-be high school senior, though, I would speculate that my affinity for neat handwriting and dedication to schoolwork drew me towards the #studygram niche.

It was through the #studyblr and #studygram communities on Tumblr and Instagram, respectively, that I discovered bullet journaling. At first, I was pulled in by the beautiful artwork I saw on social media, and when I started my own bullet journal in January 2017, I fell even harder. The flexible and completely customized planning system felt ideal, and I enjoyed

doodling and lettering as well. Learning how to optimize this planning system, I began to incorporate videos about bullet journaling into my weekly schedule.

My study tips and bullet journal videos alike seek to advise fellow students while providing snapshots of my own growth. Admittedly, some of my oldest videos seem like the blind leading the blind. As a freshman, my planning, note-taking, and studying techniques had not yet been fully refined. I still don't and likely never will possess a perfect knowledge of productivity and organization. I've read countless amounts of articles, books, and blogs about self-improvement, ranging from the details of language-learning to the power of decluttering, and tried out their tips. In each of my videos, I've provided quick guides to what has worked best for me, based on a background of extensive research.

The contents of this volume are similar to what I share in my bullet journal guides and plan with me videos—spread ideas, bullet journal tricks, and study tips that can be used in conjunction with a bullet journal. However, writing a book rather than creating short video guides gives me more space to expand upon my ideas, both in quantity and level of detail.

I've grown accustomed to writing five-minute video scripts and three-page papers, so creating this 100-page tome has pulled me at least 97 pages out of my comfort zone. Although I'm meant to be a teacher in this book, it's also been an incredible learning process for me. I also struggled with the new level of quality I expected from myself. As a recovering perfectionist, I imposed so much pressure on myself that I procrastinated out of fear of mistakes. Despite experience as a supposed "productivity guru," I too fell victim to putting things off until that last-minute panic.

Regardless of the obstacles in the writing process, I couldn't be prouder of *Study With Me*. I hope that you'll love it too. The techniques in this book are intended to serve as loose guidelines, with spreads to be used as jumping off points. You don't need to implement every technique in this book or even every aspect of each idea mentioned. Pick and choose what you feel would best suit your tastes, find out what works, swap out what doesn't, and rinse and repeat.

Most of the ideas present are organized by subject, ranging from algebra to zoology. If you're short on time, feel free to peruse just the subjects you're currently studying. However, certain tips may be categorized under one subject, but applicable to many others, so I suggest you look through all subjects.

I hope the advice I share can help you as much as it has aided me.

Happy journaling!

1
BULLET JOURNALING 101

It's often said that the first step of a journey is the hardest, and this is definitely true for bullet journaling. For those new to this journaling style, the wide range of possibilities can seem overwhelming. Simply starting the first spread can be the hardest part.

This chapter provides an overview of supplies and offers strategies for brainstorming spread ideas, choosing and creating planning setups, and creating additional setups that complement those initial choices.

When you start your bullet journal, you don't need to be perfect on the first try. This chapter provides guidelines, not hard-and-fast rules—there are no requirements in bullet journaling, and what you enjoy in your journal will depend on your preferences. Allow yourself to experiment with numerous setups, mess up, and make adjustments.

Welcome to the world of bullet journaling!

WHAT IS BULLET JOURNALING?

● ● ● Bullet journaling is a task-based form of journaling. It's a highly efficient way of planning your life and taking notes. Many areas of our lives are based on technology, but there are many benefits to handwriting your schedule and notes in something like a bullet journal (often shortened to "bujo").

There are many reasons why you may want to use a bullet journal:

- You like being organized and completing your work on time.
- You enjoy taking physical notes.
- You're constantly making various to-do lists.
- You're obsessed with gorgeous stationery (washi tape, stickers, brush pens, etc.).
- You love setting goals for yourself and reflecting on them.
- You like journaling, but just can't seem to find the right fit for you.
- You'd like to have time to do things you're passionate about.
- If one or more of these apply to you, a bullet journal would be perfect for you.

There are three main avenues a bullet journal can take: you can use it for creativity, school, or personal planning (or any combination of these). You can exclusively use your bullet journal for creativity, for example, and focus more on lifestyle pages that use spreads such as habit trackers (see pages 86–88). You can also use your bullet journal mainly for school and taking notes, all of which is detailed in chapter 2 (page 25). If you're using your bullet journal for personal planning, you'll usually be making planners, which you can find on pages 26–35. You could combine, for instance, personal planning and school to take notes as well as plan your life, as you would in an agenda. Or, you could combine school and creativity if you want to incorporate artwork and doodles into your bullet journal. In fact, you could combine all three—creativity, school, and personal planning—if you so desire.

The beauty of the bullet journal is that it's **completely customizable**. You can control everything about the book and make it as intricate or as simple as you'd like. This may seem daunting, and you may feel overwhelmed and unsure about where to start. But that's exactly what we'll be helping you with in this book. We provide examples and tips for what you can do to customize your bullet journal and give you everything you need to start. Once you're comfortable with your bullet journal, we encourage you to experiment beyond the basics we provide in this book and truly make your journal your own, in whatever way works best for you.

A colorful creative
layout by Alyssa
for the start of a
new year.

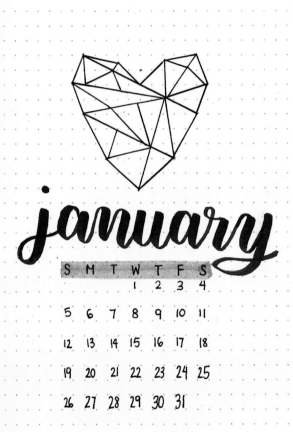

GETTING STARTED ...

1 | Gather Your Supplies

You can check page 18 for a more comprehensive supplies guide, but you'll just need a notebook and pencil to set up the bare bones of your bullet journal.

2 | Brainstorm Ideas for Spreads

The basic and most functional necessities for your journal are a table of contents and yearly, monthly, weekly, and/or daily planner setups for tracking events and tasks.

Beyond this framework, the possibilities are endless! There are many beautiful spreads to be found on social media, which can be great for inspiration but can also seem unattainable and overwhelming. It's easy to get caught up in the perfectly groomed planners you see online, but comparing your artistic skills to others' is a dangerous game. Your journal can be as minimal or decorative as you want! Keep in mind that the purpose of a bullet journal is to organize your life, not to make a perfect Instagram photo.

Throughout this book, we'll break down a plethora of ideas, ranging from study planning to exercise tracking. In addition to the suggestions we provide, you can create a Pinterest board or Instagram collection to save spreads you're interested in trying.

Once you have a general idea of which spreads and trackers suit your lifestyle needs and planning style, it's time to drill down to specific details.

THIS *bullet journal* BELONGS TO:

Bookplate hand lettered by Jasmine.

3 | Choose & Create Planning Setups

You can create planning setups for a year, six months, one month, a week, a day, an hour . . . you name it! Choose one, a few, or all of them. There's no one-size-fits-all solution; your choice depends on your personal planning style. Think about the following:

- What type of planners have you used before bullet journaling? What did you like or dislike about them?
- Do you prefer setting long-term goals or taking things day by day? Maybe it's both—you don't have to fall only into one of those two camps. Using multiple setups is a great option.
- How detailed are your plans, usually? Do you tend to have weeklong objectives, or do you plan your days down the minute?

Planning setups can also include additional trackers, such as sleep logs, meal plans, and habit trackers. Based on your brainstorming list, incorporate a few as you wish. However, if you're new to journaling, I would caution against jumping into the deep end with an exorbitant number of trackers. It seems fun to track every aspect of your life, but it's much easier to get into the habit of journaling when you start with just a few trackers that take less time and mental energy to fill out.

4 | Create Additional Setups

Once again, refer back to your brainstorming list and try out a couple of spreads. Don't limit yourself to copying others' ideas exactly; tweak them to suit your lifestyle. At the same time, there's nothing wrong with copying—it's fine to see if others' layout ideas will work for you. Just don't claim that you came up with them!

As you try different trackers and setups, reflect on what works for you and what doesn't. Does your planning setup give you too much empty space or not enough? Do you enjoy filling out a certain tracker or do you avoid it? Don't waste your time with a setup you don't enjoy; change or replace the areas that need improvement. Customization is the core of the flexibility of the bullet journal system, so make the most of it!

THE TOOLS OF THE ORIGINAL BULLET JOURNAL

● ● ● The bullet journal system was originally created by American digital product designer Ryder Carroll. You can find a full guide to Carroll's system on bulletjournal.com, but bullet journaling has no strict rules—rather, the original guidelines serve as a starting point for each bullet journaler to create a personalized planning system. In this section, we'll give an overview of the planning tools that make up the original bullet journal system, and how you can modify them to make them your own.

Bullets

The base of the bullet journal is, well, the bullet! There are three different types of bullets: an open circle for an event, a dot for a task, and a dash for a note. You don't necessarily have to stick to these original pairings—for example, I personally use an open circle for a task, an open square for an event, and a dash for a note.

However, the descriptions that follow use the original shapes as references.

Next to each bullet symbol, write your task, event, or note. Each should be a concise fragment rather than a long sentence or statement.

Task bullets can be marked in several ways to signify the status of the task. Draw an X through a dot to mark it as completed, or cross out the

SUNDAY // 13

○ club meeting - lunch
○ track meet - 3:30
 - early release @ 1:15
• unit 9 vocab
• study math FRQs
• things they carried packet

A task list by Jasmine marked with traditional bullet journal symbols.

entire line if you decide the task is no longer necessary. If a task is incomplete at the end of the day and you want to schedule it for another day, draw an arrow to mark that you are "migrating" the task. What this means is that you've either scheduled it into another planning spread, such as the future log or monthly log, or moved it to the next day.

You can also mix and match different types of bullets by using them as subpoints underneath another bullet. For example, you can have an event bullet with note bullets underneath that describe the location and dress code.

Additionally, you can add signifiers to prioritize certain bullets. In the original system, an asterisk is used to flag certain bullets as top priorities. An alternative strategy I use is ranking bullets in order of priority by writing a small number next to each one.

Index

The index, also known as the table of contents, is a map of your journal. If you're looking for a certain spread, you can quickly scan this list and immediately find the corresponding page rather than flipping through your entire journal. However, your table of contents can only fulfill its purpose if you regularly add new entries. Whenever you create a new spread, remember to record its location in the table of contents. You can find more tips and tricks about page numbering and using a table of contents on page 22 (Tips & Tricks).

Future Log & Monthly Logs

A future log is a planner setup for an entire year or more. Most journalers locate it toward the front of the bullet journal because, in general, you'll only set it up one time at the beginning of the year. Monthly logs are planner setups for one month at a time, and these can be interspersed throughout your bullet journal. These are usually set up one at a time at the beginning of each month.

Both of these setups use the aforementioned bullet system. For more information about methods of organization for yearly, monthly, and weekly planners, check out chapter 2 (page 25).

Daily Log

You can place a daily log wherever you need it, which will usually be on the first blank spread following your monthly and future logs. This section is where you write down your daily bullets, which are the tasks you need to tackle and the events occurring that day.

If you have leftover tasks from the previous day, mark them as migrated and rewrite them on the current daily log—don't just refer to daily logs from the past as your current to-do list. Besides keeping your task list collectively organized in one spot, rewriting will encourage you to reflect on whether a task is important enough to rewrite. That extra effort barrier will make you reconsider whether an action is truly necessary. By subtly nudging you to curate your to-do list, the bullet journal system allows you to cut the clutter and instead focus on what matters.

For more tips about daily planning, see page 32.

WHAT YOU'LL NEED

• • • Bullet journaling is a highly customizable system, so take these as suggestions for tools you may find useful rather than strict requirements.

Journal

The notebook you journal in can be anything from a spiral-ring notebook to a luxurious journal or something in between. The most important thing is that it should be large enough to fit all of the content you want on each spread while also being small enough to be portable and easy to store. Most bullet journals are between the sizes A6 (10.5 by 14.8 cm/4.1 by 5.8 inches) and B5 (17.6 by 25 cm/6.9 by 9.8 inches). To facilitate the preservation of your journals, you may want to consider a journal with archival-quality paper.

Additionally, think about whether you want pages that are blank, lined, grid, dot-grid, or another rule type. Each has pros and cons. A blank notebook allows for more freedom and reduces visual clutter but gives little guidance in keeping lines and columns straight. A grid notebook is at the opposite end of both spectrums—it offers many guidelines but can look cluttered. Personally, I find a dot-grid notebook provides the best balance. It has the guiding marks of a grid but looks cleaner and doesn't feel as strict or limiting.

You may also want to pay attention to paper weight, cover type, and additional features such as preprinted page numbers, but these aren't quite as important as the size or rule.

Black Pen

A humble black pen can accomplish almost anything, from writing down tasks to creating setups and more. You'll be using it a lot, so invest in a high-quality writing tool. You don't want to waste time and effort on a pen that won't write! This doesn't mean you need a $2,000 fountain pen, but do your research and find something that suits your needs. Look through specifications and reviews to select one with a tip size, ink type, and body shape that fit your preferences. These factors will determine most of your writing experience. As with the paper in your journal, you may also consider a pen with archival-quality ink to make your journal last.

Pencil & Eraser

These tools are used to sketch your layouts and drawings before making them permanent with ink. They're especially useful for more complicated drawings or designs, to prevent making a mistake that can't be erased.

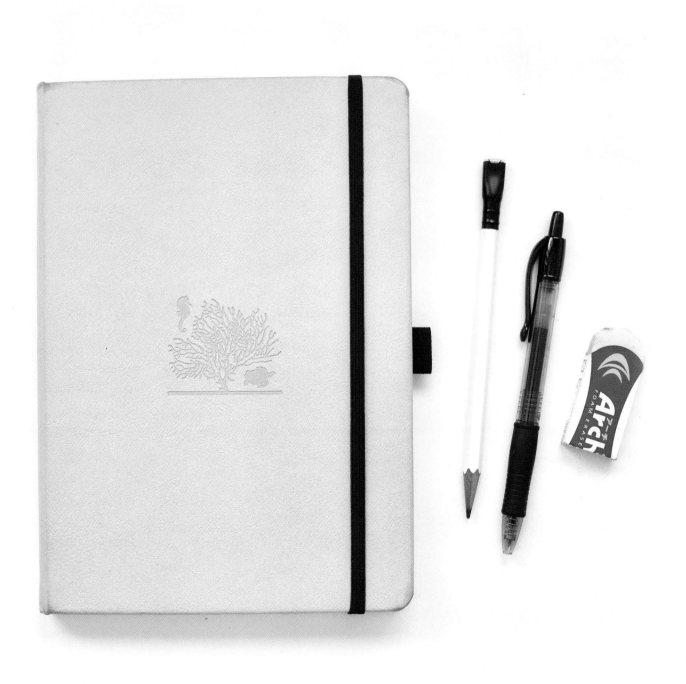

Colorful Markers or Pens

If you want to draw or add colored accents, colorful markers or pens are a must. Options can range from standard markers to highlighters to gel pens. Generally, markers are better for coloring large areas, while pens are better for writing and doing detailed drawings.

Brush Pens

Brush pens can be used both to color and to create calligraphy. (You can find a guide to calligraphy and more detailed information about calligraphy materials on page 96.) Choosing your brush pen will also require research into the many options available. Two of the most important characteristics to consider are the tip size, which determines how large your letters will be, and the flexibility. A firmer tip is easier to control, which is ideal for beginners, while a flexible tip allows for a more expressive range of line variation.

Washi Tape & Stickers

If you're not inclined to doodle, you can still add some cute visuals and colorful touches with washi tape and stickers. These can be found all over the Internet and in stationery stores in any design under the sun.

Page Flags or Bookmarks

Some journals come with ribbons to use as page markers, but yours may not have one. Or, even if it does, you may have quite a few spreads that you flip to on a daily basis—such as a daily habit tracker or monthly calendar—in which case you will need markers for all of them.

TIPS & TRICKS

● ● ● These tried-and-true tricks will help you avoid common beginner mistakes, making your journaling process more streamlined.

Use a White Pen to Fix Mistakes

A white pen can be a helpful tool for drawing and headers, but it's especially useful for fixing mistakes. It's like a very precise correction-fluid pen. If a mistake is too big to cover with the small tip of a white pen, you can color over the entire slip-up with a dark-colored marker. Then, write on top of the rectangle with a white pen. Now it looks intentional!

Glue Pages Together

Sometimes you make an error so drastic the page is unsalvageable. Don't rip it out, as that could damage your journal's binding. Instead, you can glue the two facing pages together. Once glued, they'll function as if the offending pages never existed at all—you'll just have a smooth flip from one beautiful spread to another.

Number Your Pages

If your notebook with is preprinted with page numbers, you're in luck! If not, adding page numbers is essential for tracking your spreads in the table of contents. One way to save time is to number every other page, writing either only even numbers or only odd numbers. This way, you cut your writing time in half, and you can still see a page number on every spread.

Don't worry if you accidentally miss a page when writing numbers. One option is to glue the facing pages together, as previously described. You could also add a fraction page number. It doesn't quite make sense to call something page number 28.5, but it still tells you where the page is—between 28 and 29!

Plan Your Table of Contents

A table of contents usually starts at the beginning of the journal, and you'll have to make your best guess of how many pages you'll need to use. If you don't want to predict the number of pages needed, you can start your table of contents from the back, with the first page of the table of contents being the last page of the notebook. As you fill your journal with spreads from the front toward the back, fill in the table of contents moving from the back toward the front. This ensures that when these two sides meet, the table of contents will be exactly as long as necessary.

Count Your Squares

If you have a grid or dot-grid notebook, take the time to count how many squares there are on each dimension and note this on the front page of your journal. Then, when you need to divide your spread into a certain number of sections, you can refer to this information instead of recounting every single time.

Create a Journaling Ritual

If you're having trouble sticking to your planning and organization habits, dedicate a specific time into your daily, weekly, and monthly routines to do so.

Personally, I fill out all my trackers and transfer any leftover tasks before I get ready for bed. I fill out weeklong trackers, such as my goal reflection journal, on Sunday mornings. Just like brushing your teeth after eating is a habitual task you barely need to remind yourself to do, adding bullet journaling to your routine will ensure that you actually journal.

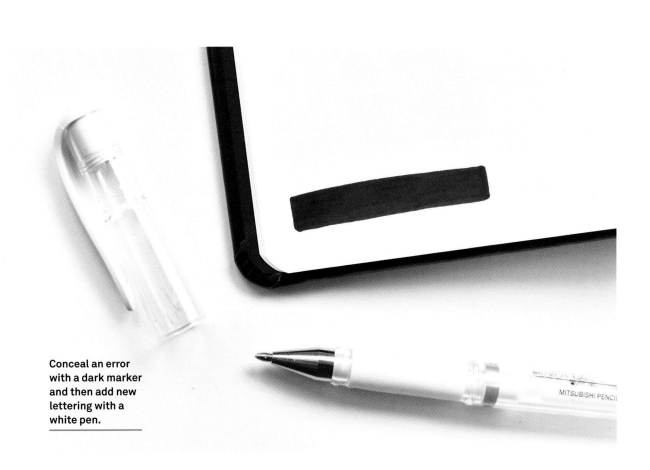

Conceal an error with a dark marker and then add new lettering with a white pen.

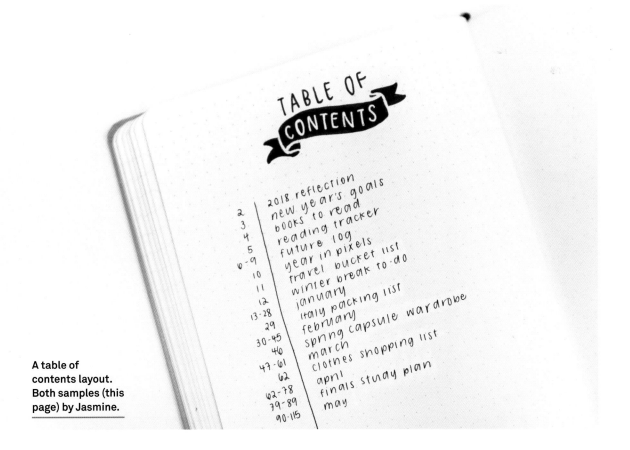

A table of contents layout. Both samples (this page) by Jasmine.

2
ORGANIZE YOUR LIFE

Now that you've mastered the basics of bullet journaling, it's time to use your journal to its maximum potential! As you've already seen, the flexible bullet journal system allows an endless range of possibilities.

In this chapter, we'll go over a variety of spread ideas. These layouts are designed for the student lifestyle, with organization and planning tips specific to students' academic schedules.

To begin, you'll learn to organize your tasks and manage your time through various schedule types, from yearly overviews to detailed daily agendas.

Next, we've created a comprehensive guide to using your bullet journal as a study tool. In this chapter, you will find detailed spread ideas, study techniques, and planning methods for every subject.

But life isn't all about academics—extra-curricular activities, health and fitness, and personal journaling are essential to your physical and mental well-being. Thus, we've also included a range of advice about these topics.

With the techniques in this chapter, you'll be able to maximize your productivity and thrive as a student. Let's get started!

YEARLY PLANNERS

● ● ● Planning an overview of the entire year is a great way to get a general idea of major upcoming events and ensure you're adequately prepared to tackle them. A yearly planner can also be a tracker for long-term goals or tasks.

For students, noteworthy events would include the following:

- Major exams and tests
- School breaks and holidays
- Special events, such as weddings or dances
- Extracurricular activities, such as concerts or volunteering

When you set up your bullet journal, whether you do it at the beginning of the calendar year, the beginning of a semester, or sometime in between, record every event you can find out about in advance. Check your school calendar and any schedules you receive from organizations you're involved with. Be sure to add events as you receive more information about them.

Since students have so much to juggle, a small calendar that fits on one page doesn't provide enough space. Instead, I recommend splitting the yearly calendar into at least two pages, if not more—in this example, I've put three months on each page for a total of four pages for the year. Always give yourself more space than you think you'll need to make sure you can fit all your plans.

A pitfall to avoid is creating a separate yearly calendar for each aspect of your life, such as creating one for tests, one for sports, and one for travel. Instead, you can visually separate these areas by writing in different colors on the same calendar. Splitting up your tasks increases the risk you'll forget to check a calendar and miss an important bullet. Also, seeing everything at once will give you a more accurate snapshot of how busy your schedule is.

The yearly planner will also be your guide when you're setting up your monthly spreads. Since your major events and tasks are already recorded in the yearly planner, when you create a monthly planner at the beginning of each month, just migrate these events and tasks into the respective monthly planner. On the next page, we'll delve into setting up and using monthly planners.

JANUARY

M T W T F S S
1 2 3 4 5 6 7
8 9 10 11 12 13 14
15 16 17 18 19 20 21
22 23 24 25 26 27 28
29 30 31

1-8 holiday break
15 MLK Jr day
28 1 pm musical
29 studyquill 2 yr. anniversary
29 planner giveaway

FEBRUARY

M T W T F S S
 1 2 3 4
5 6 7 8 9 10 11
12 13 14 15 16 17 18
19 20 21 22 23 24 25
26 27 28

19-23 winter break
25 1 pm musical
5 earbud giveaway

MARCH

M T W T F S S
 1 2 ③ 4
5 6 7 8 9 ⑩ 11
12 13 14 ⑮ 16 ⑰ 18
19 20 21 22 23 ㉔ 25
26 27 ㉘ 29 30 ㉛

2-4 IAAF indoor championships
18 1 pm musical
6 4:30 ortho
O = invitational
☐ = league meet

APRIL

M T W T F S S
 1
2 3 4 ⑤ 6 7 8
9 10 11 12 13 ⑭ 15
16 17 18 ⑲ 20 21 22
23 24 25 ㉖ 27 ㉘ 29
30

9-13 spring break
22 1 pm musical
O = invitational
☐ = league meet
17 orthodontist 4:40

MAY

M T W T F S S
1 2 3 4 5 6
7 8 9 10 11 12 13
14 15 16 17 18 19 20
21 22 23 24 25 26 27
28 29 30 31

13 16th birthday
28 memorial day

JUNE

M T W T F S S
 1 2 3
4 5 6 7 8 9 10
11 12 13 14 15 16 17
18 19 20 21 22 23 24
25 26 27 28 29 30

6-7 finals
10-21 europe trip

7

A yearly planner layout by Jasmine that gives an overview of the first six months of the year.

MONTHLY PLANNERS

● ● ● As mentioned in the previous section, the plans you track here will overlap with those you make in your yearly planner. However, in a monthly planner, you can add details to your plans and add smaller events that aren't significant enough to include in the yearly planner.

The main difference between a monthly and a yearly planner is the level of specificity. For example, if your yearly overview included reviewing for a standardized test as a monthlong objective, in the monthly planner you would break that down into smaller steps. In the case of this particular goal, you might split it up into studying math during the first week, grammar during the second week, and reading comprehension during the third.

(Below and opposite) Two approaches to monthly planner layouts by Jasmine.

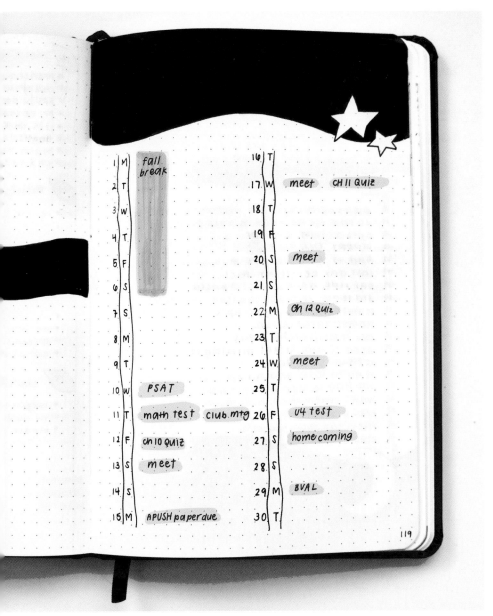

1	M	fall break		16	T	
2	T			17	W	meet CH 11 QUIZ
3	W			18	T	
4	T			19	F	
5	F			20	S	meet
6	S			21	S	
7	S			22	M	ch 12 QUIZ
8	M			23	T	
9	T			24	W	meet
10	W	PSAT		25	T	
11		math test club.mtg	26	F	U4 test	
12	F	ch 10 QUIZ		27	S	home coming
13	S	meet		28	S	
14	S			29	M	BVAL
15	M	APUSH paper due	30	T		

119

Additionally, you'll also note your smaller events and less important plans in your monthly planner. Something such as a dental appointment may not show up on your yearly plan, but you still need to plan for it and thus will note it on the monthly calendar.

One option is to set up a grid that resembles a typical wall calendar. The margin on the right is for week-long tasks, with each task written next to the week they are scheduled for. I drew a stripe with a marker to mark events that span multiple days, like spring break in the example.

Depending on the way that your schedule is laid out, you may choose not to use a monthly planner at all and instead stick to just yearly and weekly planners. You could also create a setup that encompasses a different unit of time, such as two months or three weeks. The following pages will go into more detail about weekly and daily planners and how to find your best fit.

WEEKLY PLANNERS

● ● ● Just as a monthly planner is more detailed than a yearly planner, a weekly planner is more detailed still. Continuing with the previous example of reviewing for a standardized test, if your monthly planner specified that you would study math in the first week of the month, you would use the weekly planner to schedule those math studies in further detail. You might assign two specific chapters of your review book to each day, for example.

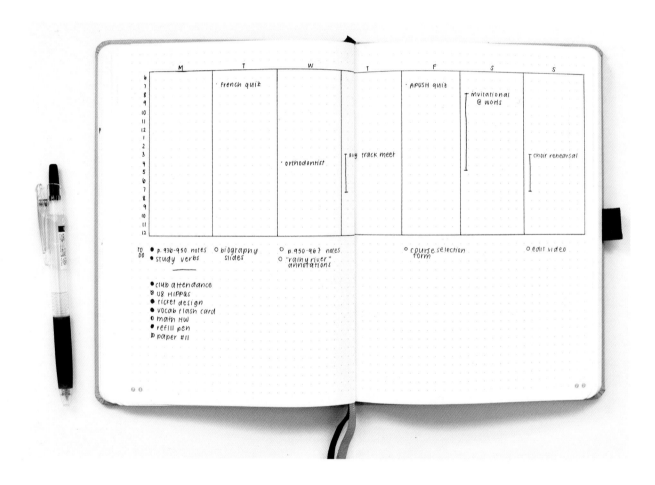

This example of a weekly planner by Jasmine has a vertical column for each day. The hourly timetable on the upper half is for scheduling events that have a set time, such as a doctor's appointment or performance. The space underneath is for daily to-do bullets. With a weekly planner like this one, a separate daily log is no longer necessary, as you simply incorporate daily bullets into the weekly setup.

A more freeform weekly planner layout by Alyssa.

A weekly planner is an ideal space to split large projects into smaller tasks—divide and conquer! Being overwhelmed is a significant cause of procrastination, and breaking seemingly insurmountable obstacles into bite-sized pieces can prevent this.

To break up a large project, list out every small step that makes it up. For example, you can split writing a literary analysis paper into reading the book, annotating, writing a thesis, writing an outline, writing the introduction, writing the first paragraph, and so on. Then, assign each step to a specific day. You can assign an equal workload to each day or shift the balance based on how your schedule varies. It's all up to you!

To learn more about breaking up projects to prevent procrastination, check out page 56.

The distinction between a daily and weekly planner can be unclear, as a daily event plan or to-do list is often embedded in a weekly planner. Thus, it's generally not essential to have both daily and weekly planners. In the next section, you'll learn more about daily planners and how to decide which planner setups would be right for you.

Weekly Planners for Time Management

There are many options for weekly layouts. I would recommend using a weekly planner if you want to look at your whole week and only one week at a time. Many people prefer this, as you can look far enough ahead to stay on top of things but not get overwhelmed. I find it's the perfect fit for me because it's too time consuming for me to set up a new page for every day, and monthly spreads don't provide enough detail. I use three main types of weekly spreads: simple, highly structured, and student specific.

- **Simple.** This type of spread is similar to what you'd find in a purchased agenda, in which there are specific areas or boxes for each day. This layout is minimalistic and clean; it's the most time-efficient spread and very practical and easy to keep up with. I recommend this layout if you're intimidated by more intricate spreads or have limited time to dedicate to your bullet journal.

- **Highly Structured.** This layout tends to be time-based, whether you section it off by hours or by morning, afternoon, and evening. This is perfect if you want more structure to track what you can actually accomplish in a day than what you would have in a simpler format. I find this layout works well for people who are juggling many different projects and need to track their time very precisely.

- **Student Specific.** Another possibility is to section off your bullet journal by classes, which can be very helpful for students. This makes it easy to see what you need to get done in each class, as you can list your priorities in each one as well as how you're breaking down large projects and when you aim to have each section of those projects done. Whether you're on a semester system or something else, a student-specific layout is great for organizing your school life on a weekly basis.

DAILY PLANNERS

● ● ● Of all planner types, a daily planner includes the most detail, as it's specific to each individual day. Depending on how many events and tasks you have, a daily planner can require anywhere from a few lines to a full page.

You can use a simple bullet list, as seen in the example on page 16 (Tools of the Original Bullet Journal), or a more complex setup.

The example to the right uses the Eisenhower Matrix, a system in which you categorize your tasks based on whether they are urgent or important. Here's how you prioritize based on categories:

- Urgent and Important—do it now
- Not urgent but important—do it now or schedule it for later
- Urgent but not important—delegate it
- Not urgent and not important—find a way to eliminate it from your to-do list

As mentioned in the weekly planner guide, you can use a daily planner in place of a weekly planner. You don't necessarily need to use all the planner types previously discussed because bullet journaling is flexible, and what setup works best varies from person to person. The planner types you choose will depend on your planning style and schedule. Here are a few factors to consider.

Degree of Detail

A planner that's specific to a smaller time period, such as a single day, will give you space to plan in greater detail. On the other hand, a larger time period, such as a year, gives you a general overview of what's coming up. I recommend picking at least two levels of detail, one for a big-picture overview and one for more minute plans.

Amount of Space

As mentioned, a daily planner will allow you to include many more details. This is especially helpful if you have a lot of events or tasks and enough room to record them all. On the other hand, if you don't have a lot of things to record every day, a daily planner may be a waste of space. If you don't see yourself filling up the all the room allotted to a setup, avoid wasting your journal pages with too much empty space.

Time Commitment

Using more planner types allow you to plan in more levels of detail. However, you'll also need to spend more time and effort to keep up with them all. Consider the time commitment required to set up all the spreads and copy plans into each one. Using more planners will also increase the risk of forgetting to write a certain event or task on a certain spread and as a result, forgetting to attend the event or complete the task.

Cyclical Schedules

Your personal schedule can follow cycles—for example, my schedule follows a weekly cycle because I have sports competitions and choir rehearsals on a weekly basis. It's best to pick a planner setup that will align with the cycles of your own schedule.

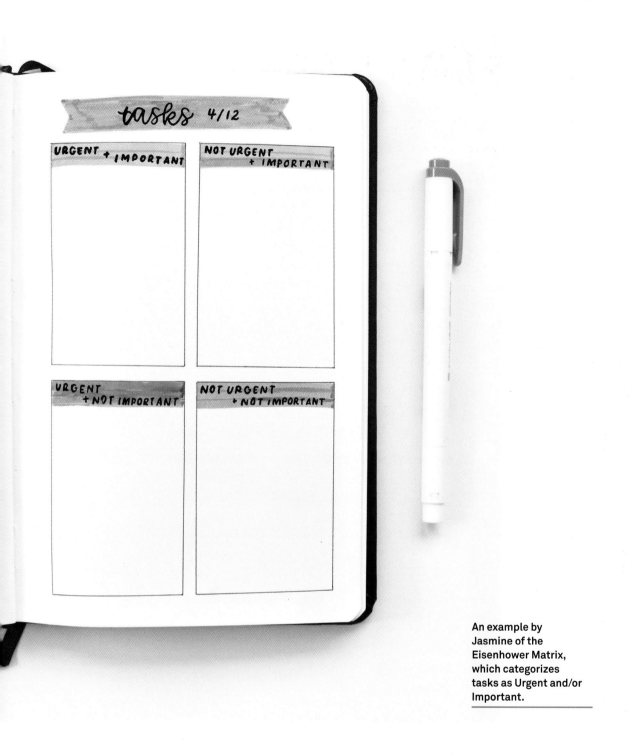

An example by Jasmine of the Eisenhower Matrix, which categorizes tasks as Urgent and/or Important.

You can also change up the planner types you're using based on how busy you are. For example, I use both monthly and daily setups in April, when I'm busy with track meets and studying for final exams. On the other hand, over the summer, I only use monthly spreads because I don't have as many plans.

PLANNERS FOR STUDYING

● ● ● Creating an Exam Study Schedule

Making a study plan for a huge test or final exam can be an overwhelming prospect, as there's just so much material to review. But by simplifying large amounts of information into smaller steps and creating a detailed schedule, you'll be sure to thoroughly cover everything without too much stress. Here are the steps for creating a study schedule.

A sample study schedule by Jasmine.

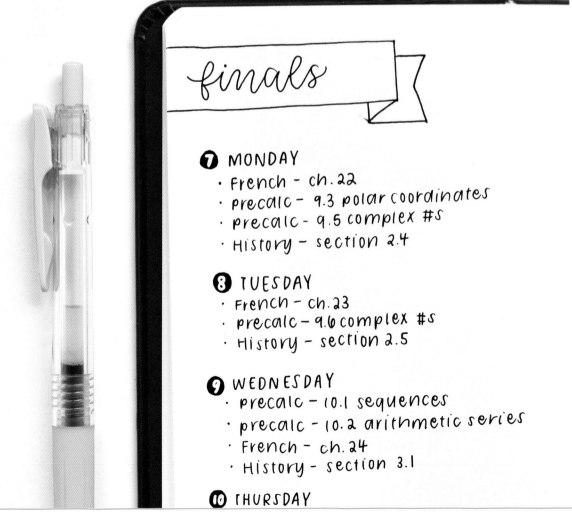

finals

❼ MONDAY
- French – ch. 22
- precalc – 9.3 polar coordinates
- precalc – 9.5 complex #s
- History – section 2.4

❽ TUESDAY
- French – ch. 23
- precalc – 9.6 complex #s
- History – section 2.5

❾ WEDNESDAY
- precalc – 10.1 sequences
- precalc – 10.2 arithmetic series
- French – ch. 24
- History – section 3.1

❿ THURSDAY

1 | Count Your Sections

There are a few different resources you can use to determine how to divide up the material you need to study—the sections of your textbook, a review book, or your notes, to name a few. You could call your divisions chapters, sections, units, or something else entirely. Generally, each should be an amount of information that would be covered in one lecture.

Create a list of all the sections you will need to know for the test and then count the number of sections. To do this more quickly, type them into a numbered list in a word-processing program so you don't need to manually count the number of list items.

2 | Count Your Days

How many days are there before the exam? Or, if you're planning far in advance, how many days will you spend studying? The more days in the schedule, the less you need to study on each day. Don't cram everything into the last few days before a big exam, especially because you should spend those days resting. On the other end of the spectrum, spreading everything over a longer period than six weeks is not optimal either, as you risk forgetting the information you studied at the beginning of your preparation period. Personally, I prefer a period of three to four weeks to review for a final exam and one to two weeks for a large test.

3 | Divide Them Up

Next, assign certain sections to each day. Write the specific title or number of the section as a task bullet on its corresponding day. The amount of work you assign to each day can vary depending on how busy you are—some days you'll have more time to study, while other days you'll have a lot of other things going on.

Chances are the number of sections will not divide perfectly into the number of days. When this happens, assign more rather than fewer sections to each day. It's better to front-load your study period and end up with almost nothing on the days leading up to the exam. On these buffer days, you can review the material you struggled more with or do a practice test that covers all the material.

4 | Make Your Game Plan

Now that you know what information you'll review each day, figure out exactly how you'll tackle it. Don't just write "study section 2.1" as your task bullet—for each section, specify exactly what type of studying you'll be doing and how long you'll be doing it. Some good examples would be "Do 30 multiple choice questions from section 2.1" or "Practice chapter 3 short answer questions for 20 minutes." Don't fret if you're not sure about which study methods to use yet; throughout this chapter, we'll give tips and tricks specific to each subject.

5 | Follow Through

Planning is one of the hardest steps in studying. The next hardest is, well, actually studying! Creating your study plan helps you feel less overwhelmed and gives you clear direction, thus preventing procrastination. Nevertheless, if you are struggling to avoid procrastination, check out page 56 for advice.

6 | Reflect & Correct

It's natural to miss a study session every once in a while—student life is hectic, and unexpected circumstances are all too common. If you don't finish a task, simply reschedule it to another day.

Additionally, if you found a section particularly difficult, be sure to note this on your study plan by drawing a star or highlighting it. This way, during the final days before the exam, you can easily see what you need to go back and review again.

MANAGING YOUR TIME

● ● ● We're all busy people with a lot going on in our lives, so whatever time we do have, we need to be using it effectively. As a student with many extracurricular commitments who also has hobbies and passions outside of school, I understand how important this is. There are endless ways to organize your days and manage your time, but I'd like to share a few of the tips that work best for me.

Plan Ahead

This may seem obvious, but planning ahead is crucial to starting your week off right. On Sunday night, I look ahead at the upcoming week and schedule my days. I make notes of any "events" I'm taking part in that week, by which I mean anything that I have to be in a specific place for a specific amount of time. This includes school, lunch meetings, after-school activities, and any other commitments I have. Make sure you also schedule in the time you'll be spending with friends or relaxing by yourself.

You can go about making your list in various ways. One is to simply make a list with the days of the week and make a bullet-point list for each activity. If you prefer a more detailed approach, use the calendar blocking method, in which you schedule your days in blocks of time.

Make Lists

Depending on what type of list you're making, one approach may be more beneficial to you than another. Personally, I make lists based on school subjects: for each class, I list each thing I'm working on and, next to each one, when it's due. For this method, I do this physically with a pen and paper. It's very satisfying to tick off work that you complete.

Schedule Time for Your Passions

As I mentioned, it's important to schedule time not only for commitments related to school or other activities you partake in but also for time you are spending with friends. Don't forget to schedule time for hobbies and passions because without this, it's easy to burn out. Burnout is due to constant stress, and organizing your life is a way to manage this stress.

Make Projects Manageable

I've learned to break down large projects or assignments into manageable, bite-sized pieces, and it's been a lifesaver. It's very easy to become overwhelmed when you're given a large project or assignment with a looming deadline, but by breaking it down into small sections and giving yourself a deadline for each one, the project becomes more achievable. For more on this, check out the section on page 56.

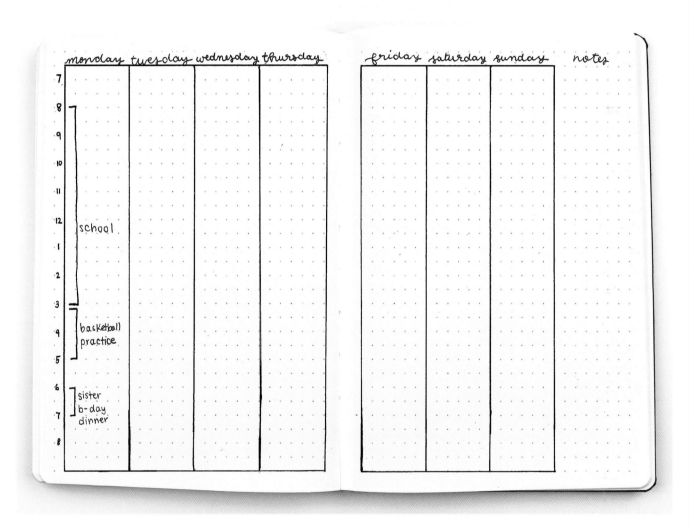

A weekly layout by Alyssa that can be used to schedule and track tasks, assignments, and events by the hour and includes an additional column for notes.

ALGEBRA

● ● ● Algebra is when math begins to get complicated, meaning there are more opportunities to slip up. Our tips on note-taking and studying, which we'll share throughout this chapter, will help you avoid making errors on tests and quizzes.

However, this doesn't mean you'll never mess up—everyone makes mistakes! Whether you slip up on homework, practice problems, or an assessment, identifying pitfalls and correcting misunderstandings will help you avoid repeating those same mistakes in the future. Here's a guide to a bullet journal spread designed to help you reflect on and learn from your mistakes, using algebra as an example.

1. First, divide your spread into three columns: a small one on the left and two large ones dividing the rest of the page.

2. The small column is for the location of the problem, such as "Section 5.4 homework" or "Chapter 2 test," and the date of the assignment.

3. In one of the larger columns, copy down the question text exactly as it appears in the original problem. Then, copy down your previous work up to the step where you first made a mistake. At this point, switch to a different color and complete the problem with the correct work. Use an answer key or ask someone else for help to make sure the corrected solution is actually correct—you don't want to "correct" your mistake into another mistake.

4. In the last column, describe the mistake in words and make a plan to avoid repeating that mistake. Some options would be asking a teacher or tutor to correct misunderstandings of key concepts, checking your work more thoroughly, or doing more practice with the problem type.

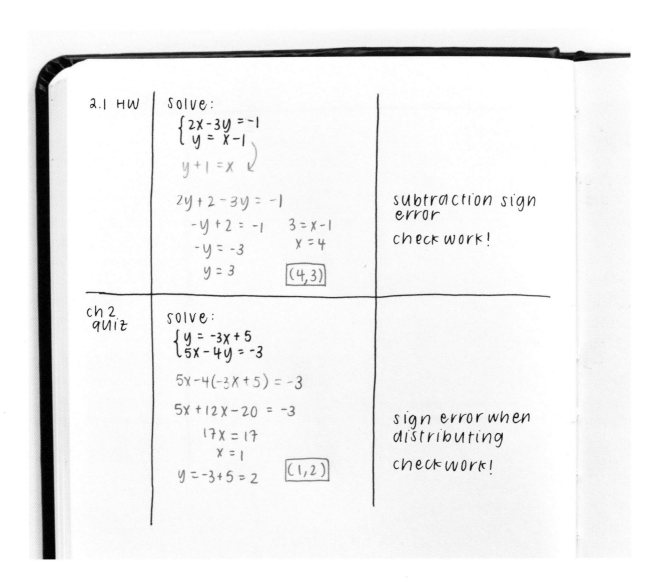

| 2.1 HW | solve:
$\begin{cases} 2x - 3y = -1 \\ y = x - 1 \end{cases}$

$y + 1 = x$

$2y + 2 - 3y = -1$
$\quad -y + 2 = -1 \qquad 3 = x - 1$
$\quad -y = -3 \qquad\quad x = 4$
$\quad y = 3 \qquad\quad \boxed{(4, 3)}$ | subtraction sign error

check work! |
| ch 2 quiz | solve:
$\begin{cases} y = -3x + 5 \\ 5x - 4y = -3 \end{cases}$

$5x - 4(-3x + 5) = -3$

$5x + 12x - 20 = -3$
$\quad 17x = 17$
$\quad x = 1$
$y = -3 + 5 = 2 \qquad \boxed{(1, 2)}$ | sign error when distributing

check work! |

A three-column layout by Jasmine for working on algebra and other equations that allows you to easily identify errors.

GEOMETRY & TRIGONOMETRY

● ● ● In geometry and trigonometry, information is often spread out, with definitions, postulates, formulas, proofs, example problems, and more combined into one chapter or lecture. This gives you a variety of information about a particular topic, such as learning everything you need to know about circles, but can be confusing when you need a concise reference to study from.

In your bullet journal, you can create your own reference guide for a quick, easy way to find information. Reorganizing the information prompts you to consider how certain facts are related, forming new connections and deepening your understanding. Also, rewriting formulas, definitions, and other facts by hand will help you memorize the information.

This section includes tips for how to organize proofs, definitions, and other information you learn in geometry and trigonometry classes.

Two-Column Proofs

One of the best ways to remember a theorem is to prove it yourself—you'll understand why the statement is true and thus will be able to remember it more easily. Also, every time you create a proof, you train your ability to tackle proofs and hone your problem-solving skills.

If you're struggling for more than fifteen minutes with little to no progress, search for a proof online. Whether or not you come up with the steps yourself, write them down and understand what's happening. If you're not sure how certain steps work, be sure to ask a teacher or tutor for help.

You can color-code your proofs by topic to make it easier to find certain ones. For example, you might use pink for right triangles and green for angles. The color code can help when you need guidance for next steps on a proof question; when browsing your theorem pages, you can keep an eye out for the topic color that corresponds to the problem you're working on.

Since two-column proofs can be long and vary in length, you won't necessarily be able to allocate precisely one spread for each topic. The best option is adding them in chronological order as you learn them. A bold title can be the most helpful way to organize—clear labeling will make it easy for you to skim your reference pages and quickly find the theorem you're looking for.

quadrilaterals

PARALLELOGRAMS

 A quadrilateral with both pairs of opposite sides parallel.

- Consecutive Angles Theorem Consecutive ∠s of a ▱ are supplementary

- Opposite Sides Theorem Both pairs of opposite sides of a ▱ are ≅

- Opposite Angles Theorem Both pairs of opposite ∠s of a ▱ are ≅

- Diagonal Bi-sector Theorem The diagonals of a ▱ bisect each other.

RECTANGLES

 A quadrilateral w/ 4 right angles. A type of parallelogram.

$\overline{CB} \cong \overline{AD}$
The diagonals are ≅

RHOMBUSES

 A quadrilateral w/ 4 congruent sides. A type of parallelogram.

 The diagonals of a rhombus are ⊥.

The diagonals of a rhombus bisect a pair of opposite ∠s.

A quick-reference summary by Jasmine on quadrilaterals in geometry.

Definitions, Postulates, Formulas & More

The previously discussed method of organizing two-column proofs can also be applied to these shorter statements. In fact, they're easier to organize because they take less space. In this case, you might want to assign a spread or two to each chapter or topic. You could also add them chronologically and color-code by topic, as suggested for two-column proofs.

Definitions will often include diagrams that illustrate the meaning of the written description. You can find advice on drawing diagrams on page 63 (Earth Sciences). For geometric diagrams in particular, precision is paramount. Use a ruler to draw straight lines and a compass for neat circles. Be sure to use a sharp pencil or fine-tipped pen so that your points, arrow tips, and lines are clean and crisp.

The Unit Circle

Memorizing unit circle values is a major challenge in trigonometry. A bullet journal can aid you in remembering the angles and points.

First, draw the unit circle or print a fill-in-the-blank example. It's essential that the shape of the circle and the angles are in ink and that the actual values have not yet been filled in.

Then, study with this page by filling in all the values in pencil. Once you've completed it and checked your work, erase your pencil markings. Since the shape of the circle is in pen, it won't be erased, leaving it ready to be reused.

unit circle

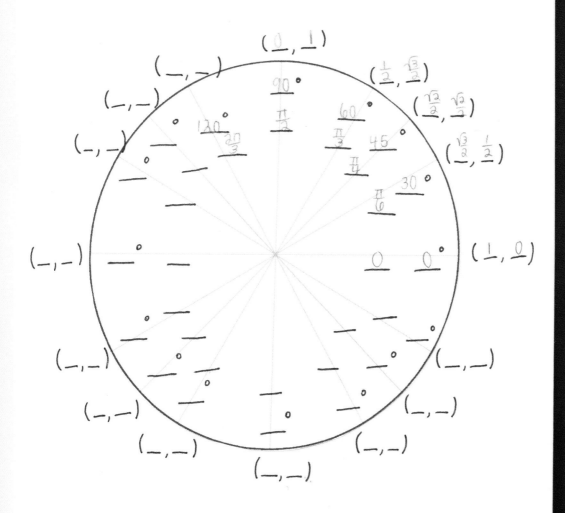

A study guide by Jasmine for memorizing unit circle values.

PRECALCULUS

● ● ● Precalculus covers many other math concepts, including algebra, trigonometry, and analytic geometry. This course provides a strong foundation for the study of calculus. Some of the topics covered are vectors and matrices, probability, sequences and series, functions and graphing, and polynomials. There are a lot of graphs in precalculus, so we strongly recommend having a table of contents to organize the content. This will allow you to easily find the information you are looking for.

Additionally, learning to sketch and label graphs is an important skill you must master. You can make sketches in your bullet journal to illustrate many important concepts, such as:

- functions vs. relations
- properly labeled graphs
- independent vs. dependent variables
- domain vs. range
- function notation

You'll learn what the curve of each base function looks like. The next step is to learn how the transformations change the curve. Your bullet journal is an ideal place to sketch the base functions and their transformations. It is also a good place to record the transformation formula and define what each term means.

Ideally, for each type of function, there should be a sketch of the base function, and then a sketch of each transformation so that you can easily see how each transformation affects the curve. These pages will also be helpful for review when you are studying calculus. The last sketch should improve your comfort level with going from the base function (e.g., $y=x^2$) to the transformed function equation (e.g., $y=a\{k(x-d)^2\}+c$).

You should use your bullet journal to become comfortable transforming the following functions:

- absolute value function
- constant function
- cubic function
- exponential function
- identity function
- inverse function
- logarithmic function
- parabola function
- reciprocal function
- square root function

Sample solutions in your bullet journal will also be useful so that you can refer to those to answer questions.

As you'll see, there are many ways to use your bullet journal to aid in your study of the other topics in precalculus as you progress through the course. These are only a few of the ways your bullet journal will be helpful for your understanding and review of precalculus.

absolute function
GRAPHICAL TRANSFORMATIONS

$$f(x) = 2|x|$$

$$f(x) = |x|$$

d

$-c$

$$f(x) = -2|x|$$

$$f(x) = -2|(x-d)| - c$$

A sample layout by Alyssa that illustrates graphing absolute value functions.

CALCULUS

● ● ● Calculus is one of the most difficult subjects, requiring both an advanced level of math knowledge and a strong memory for formulas. These methods will help you take detailed and thorough notes.

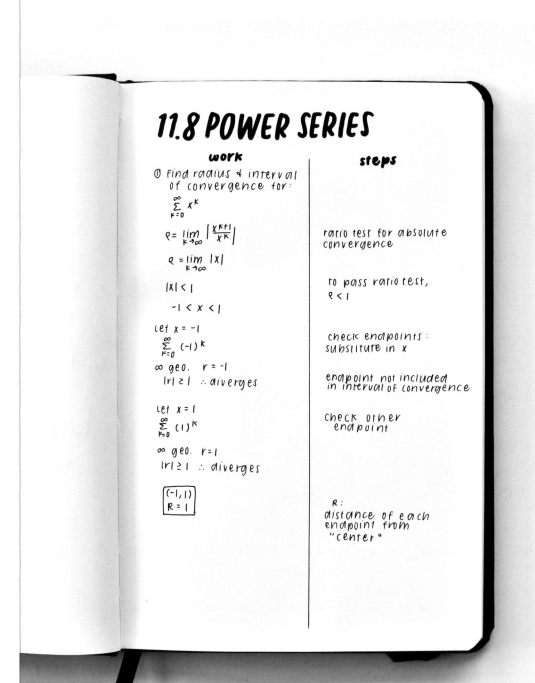

11.8 POWER SERIES

work	steps
① Find radius & interval of convergence for: $\sum_{k=0}^{\infty} x^k$	
$\rho = \lim_{k \to \infty} \left\| \frac{x^{k+1}}{x^k} \right\|$	ratio test for absolute convergence
$\rho = \lim_{k \to \infty} \|x\|$	
$\|x\| < 1$	to pass ratio test, $\rho < 1$
$-1 < x < 1$	
let $x = -1$ $\sum_{k=0}^{\infty} (-1)^k$	check endpoints: substitute in x
∞ geo. $r = -1$ $\|r\| \geq 1$ ∴ diverges	endpoint not included in interval of convergence
let $x = 1$ $\sum_{k=0}^{\infty} (1)^k$	check other endpoint
∞ geo. $r = 1$ $\|r\| \geq 1$ ∴ diverges	
$\boxed{\begin{array}{c} (-1, 1) \\ R = 1 \end{array}}$	R: distance of each endpoint from "center"

Two layouts for calculus by Jasmine. One illustrates the two-column approach for example problems with steps (left); the other, a three-column table for studying derivatives and integrals.

Two Columns: Example Problems with Steps

It can sometimes be difficult to understand the reasoning behind certain steps when you're learning example problems in class. This method will help you record the steps so they're easy to understand when you refer to your notes.

Start by setting up two columns in your notes. The first column is for the work itself. Writing the work in a column will make sure the steps are in a clear sequential order—rather than being spread out all over the page, they'll be in order from top to bottom.

In the other column, explain each potentially confusing step in words. You might also include the formulas or definitions being used, too. If you're struggling to understand how certain steps follow one another, ask the teacher for help later.

Derivative & Integral Tables

To aid your memorization of derivatives and integrals, organize them into tables. This handy reference will also double as a set of flashcards.

A derivative and integral table has three columns that are about the same size. In the middle column, write the function. You can highlight the functions or write them with colored pens to color-code by type, such as pink for trigonometric functions and yellow for logarithmic functions.

In the left column, write the derivative of that function. In the right, write the integral. Don't forget to add C!

To review, cover up either the integral column or the derivative column and quiz yourself. Another option is to cover up everything but the derivative column and practice integrating those functions or to cover everything but the integrals and take the derivatives of those integrals.

Derivative	Function	Integral		
$\frac{1}{x}$	$\ln x$	$x \ln x - x + C$		
$\frac{1}{x \ln b}$	$\log_b x$	$\frac{x \ln x - x}{\ln b} + C$		
e^x	e^x	$e^x + C$		
$a^x \ln a$	a^x	$\frac{a^x}{\ln a} + C$		
$\cos x$	$\sin x$	$-\cos x + C$		
$-\sin x$	$\cos x$	$\sin x + C$		
$\sec^2 x$	$\tan x$	$\ln	\sec x	+ C$
$-\csc^2 x$	$\cot x$	$\ln	\sin x	+ C$
$\sec x \tan x$	$\sec x$	$\ln	\sec x + \tan x	+ C$
$-\csc x \cot x$	$\csc x$	$\ln	\csc x + \cot x	+ C$

STATISTICS

● ● ● Statistics comprises four main areas:

- Exploring data
- Planning and conducting a study
- Probability
- Statistical inference

A bullet journal can be a useful tool for studying statistics. The following are a few ideas to implement:

- Make a list of key terms with their definitions.
- Make a list of symbols, what they mean, and when each is used.
- Make a list of formulas and when each is used.
- Keep an updated list of resources—books, websites, videos, and more.
- Draw examples of organizing data using bar graphs, Venn diagrams, and two-way tables.
- Draw examples of frequency tables, dot plots, histograms, and stem-and-leaf plots.
- Sketch and label various types of distributions.
- Sketch a histogram and compare the mean, mode, and median.
- Sketch a box plot and explain how to interpret and understand outliers.
- Sketch the standard deviations for normal distributions with the empirical rule.
- Sketch and interpret regression lines.
- Draw a tree diagram and an explain how to determine probability.

- Make a table comparing various distributions—uniform, binomial, geometric, and hypergeometric.
- Make a table to compare Type I and Type II errors.
- Make sample questions to aid in review.

The above isn't a complete list of ways to use your bullet journal in the study of statistics— as you get comfortable using a bullet journal, you'll find more ways to incorporate statistics notes. Your bullet journal is a great place to have examples of these things so that you can review and reference them easily. Remember to title and label your graphical displays appropriately.

You can also use your bullet journal to summarize various concepts with labeled diagrams and tables to serve as a review. This summary can synthesize material from various sources to make a complete picture.

By gathering the information and organizing it in your bullet journal, you will be cementing your understanding of the concepts. Also, it will be quick to refer to the important key terms, formulas, symbols, and more because they'll all be listed in one place.

probability formulas

name	formula	
rule of addition	$P(A \cup B) = P(A) + P(B) - P(A \cap B)$	
rule of multiplication	$P(A \cap B) = P(A) \cdot P(B	A)$
rule of subtraction	$P(A') = 1 - P(A)$	
combinations	$nC_k = \dfrac{n!}{k!(n-k)!}$	
binomial distribution	$P(x=k) = \binom{n}{k} p^k (1-p)^{n-k}$	

A layout by Alyssa for statistics that serves as a quick
guide to essential probability formulas.

FOREIGN LANGUAGES

• • • Vocabulary

Since you'll often be carrying your bullet journal with you, it's a great place to quickly jot down new vocabulary words whenever you come across them. Whether you're learning the basics for travel or working toward fluency, organizing your vocabulary is a key part of learning.

Here are some key details you may want to note for each word:

- Part of speech (noun, verb, adjective, etc.)
- Usage in an example sentence
- Translation in your native language
- Definition in your target language
- Photo or drawing

When possible, include a visual representation of the word and a definition in your target language rather than your native language. This will help you master the language because you will link the new vocabulary word with its associated concept, not just the word in your native language. Creating this direct connection will help you write and speak more fluidly because you can directly recall vocabulary in your target language rather than translating it from your native language.

Organizing Alphabetically

One option for organizing your vocabulary words is to divide your journal up by letter and add words to each letter category as you learn them. It's like you're constructing your own dictionary, making it quick and easy to find a word. However, this may not make sense for languages that use logographic symbols, such as Chinese and Japanese. Additionally, you risk the organizational dilemma of running out of space under a certain letter.

Organizing by Topic or Chapter

If you are learning vocabulary from a textbook organized into topics such as clothing or weather, you can group words from the same topic together. Grouping information from the same section together can also be helpful when you're studying for a quiz or test. The downside is that these groupings can make it harder to find individual words.

Organizing Chronologically

There is no particular rhyme or reason to a chronological list—you simply add words as you learn them. This requires the least time and effort to maintain but can feel more disorganized.

Study Tip

There's no need to create flashcards—you can use your vocabulary lists instead! Cover everything but the word with a blank sheet of paper to quiz yourself on its meaning. You could also cover the definition and think of the word. Afterward, mark the words you struggled with and practice those more.

VOCABULAIRE
les vêtements

 un gilet
a cardigan

 un anorak
a ski jacket

 un imperméable
a raincoat

 un maillot (de bain)
a bathing suit

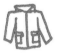 un jean
jeans

 un short
shorts

 un t-shirt
a t-shirt

 des bottes
boots

 des chaussettes
socks

A list by Jasmine of clothing-related French vocabulary words supplemented with simple illustrations.

SI CLAUSES

si + présent, présent	si j'ai une baguette, je la mange.
si + présent, futur	si j'ai une baguette, je la mangerai.
si + présent, imperatif	si tu as une baguette, mange-la.
si + imparfait, conditionnel présent	si j'avais une baguette, je la mangerais.
si + plus-que-parfait, conditionnel passé	si j'avais eu une baguette, je l'aurais mangé.

Grammar

You can also use a bullet journal to organize grammar rules and corresponding examples. In this example, I've divided a spread into two columns. I write grammar rules in the first column and sentences that exemplify those rules in the second.

Seeing examples that correspond with a grammar rule solidifies your understanding since it can often be hard to comprehend a theoretical grammar rule without a concrete example of its usage. Writing out the example sentences by hand will also help you remember them better, and by remembering sentences and their patterns, you won't need to put much effort into memorizing rules. Instead, you'll be able to create new sentences based on grammar patterns that you already know.

今天早上我去了牙医。我有需要拍几个
 dentist

X射线因为我快能去掉我的牙套。
 remove braces

然后，我和爸爸去了邮局。我申请了一个
 post office apply

新护照。我们排队排了三个小时！
passport

Grammar-related layouts by Jasmine that emphasize rules and new vocabulary with color coding and/or underlining.

Journaling

A bullet journal is called a journal for a reason—you can use it not only for studying and organization but for personal journaling as well.

You can combine your study of a foreign language with personal journaling by writing your journal entries in your target language. Writing often will hone your grammar and writing skills.

Journaling about your daily life will require you to search for vocabulary words that you might not have encountered before. Then, you can either annotate these words in your journal entries or add them to your vocabulary list, as discussed on the previous page.

You don't necessarily have to write about your personal life, either, especially if you want someone else to check your grammar and vocabulary usage. You can also write short stories, or long stories, or informational essays, or anything you want! Simply use your bullet journal as an opportunity to practice your writing skills while also expanding your vocabulary.

You can find more ideas for personal journaling on page 90.

Organizing a Reading List

Reading books is an ideal way to learn a language: it exposes you to new words, sentence structures, and grammar patterns. You'll see how the language is used in everyday life, not just in academic textbooks.

In your bullet journal, you can track the books you want to read and the ones you've already read. These tips and ideas aren't limited to just the books you read to learn a foreign language, as they can be applied to everyday reading as well.

A simple list can keep track of the books you want to read. Be sure to include the title and author in each entry. You may also want to list the genre and year of publication. A reading list can feel like a commitment to finish all the books you list, but feel free to simply cross out a book if you're no longer interested in reading it. Life is too short to waste on trudging through a book you don't like!

Your reading list can also double as a "books read" spread—just check off the books you've completed. Here are some ideas of what you can track in this type of spread:

- Date started and completed
- Rating out of 5 stars
- Short written review
- Favorite quotes or facts
- New vocabulary words (can also be recorded in a vocabulary spread, as previously discussed)

You could even make each category into a separate spread if you have a lot to write, especially for wordier categories such as reviews or favorite quotes.

books read

Title	started	Finished	Review
Murder on the Orient Express	4/07	5/01	★★★★
Hill billy Elegy	7/10	7/21	★★★
Bossypants	7/23	7/23	★★
Everybody Lies	8/01	8/03	★★★★
The New Jim Crow	8/17	9/01	★★★★
The Little Book of Skin care	8/23	8/24	★★★
Secrets For the Mad	8/23	9/16	★★★
The Candy makers	9/18		

A sample reading list by Jasmine that tracks start and finish dates for each title and includes a column for a starred review.

LANGUAGE ARTS

• • • Managing Large Assignments

Learning how to break down large projects or assignments is very important, especially if you find yourself procrastinating, feeling over-whelmed, or unable to figure out where to start. This step-by-step strategy will help you break down a project into manageable chunks.

1. Begin by carefully reading the assignment to figure out what is required. Is this a research project or an essay? Do you need to have a thesis and proof? Do you need to research and explain facts?

2. Set self-imposed deadlines for various parts of the project. Make sure to schedule your final deadline so that you have the project completed a few days before it's due so that if something unexpected happens, you still have time to finish the assignment. Do not try to do your project all at once; you have to take the time to process the information. The earlier you can start working on your project, the better it will be.

3. Edit your work a few times to check for spelling and grammar, flow of information, and concise wording. Polish your writing and make it the best you can.

4. Look over the assignment rubric or instructions to make sure you've met all the requirements.

Essay Writing

For an essay, you need a thesis and proof for your thesis. For this type of assignment, you have to research to figure out your thesis. While you read, make notes from each source. Study many sources until you feel like you have enough information to form a thesis. The next thing to do is to find three points that prove your thesis and then find two or three pieces of supportive evidence for each point. At this stage, the framework of your essay is complete, and you merely need to expand on the points. Be sure to read through and edit your work a few times before turning it in.

Bibliographies: An Important Note

You should be keeping track of each source you access during the research process. By doing this, at the end of writing your essay, you have a list of sources already made and simply need to put it into the required format. Making notes from each source along the way will also help when it comes time to do citations because you'll know where each quote came from and won't have to waste time looking through all of your material to figure out the source. Your bullet journal is a great place to keep track of all of these important pieces of information.

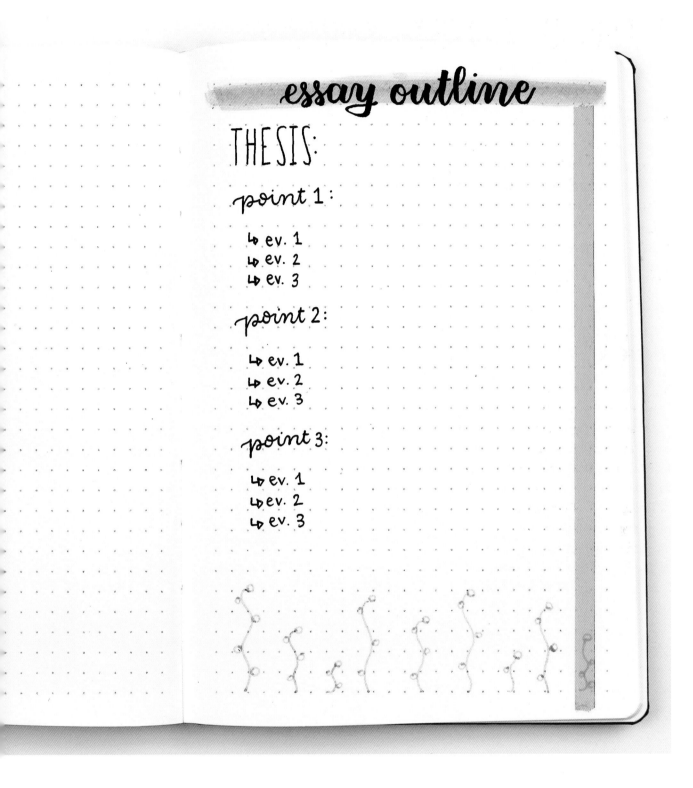

essay outline

THESIS:

point 1:
 ↳ ev. 1
 ↳ ev. 2
 ↳ ev. 3

point 2:
 ↳ ev. 1
 ↳ ev. 2
 ↳ ev. 3

point 3:
 ↳ ev. 1
 ↳ ev. 2
 ↳ ev. 3

A basic framework for outlining an essay by Alyssa.

Creative Writing

You may take a course such as creative writing, have a creative assignment in another class, or simply want to be creative outside of school. A bullet journal is the perfect place to do that.

If you're doing any sort of creative writing, such as creating screenplays, novels, or short stories, you can use your bullet journal to create reference guides. By this, I mean lists based on various topics relevant to your writing that you'll refer back to as you work on your project. You can create lists such as "The Most Popular Baby Names from the 1920s" if you're writing historical fiction, or "Ways to Describe Hair" if you find yourself constantly using the same adjectives. You can create lists such as "Signs of Confusion" if you're struggling to show that particular emotion. This can help you "show instead of tell" in your writing. Having these lists that you can always refer back to is very helpful, no matter what project you're working on. There are endless possibilities—you can create character profiles, world-building notes, timelines, and so much more.

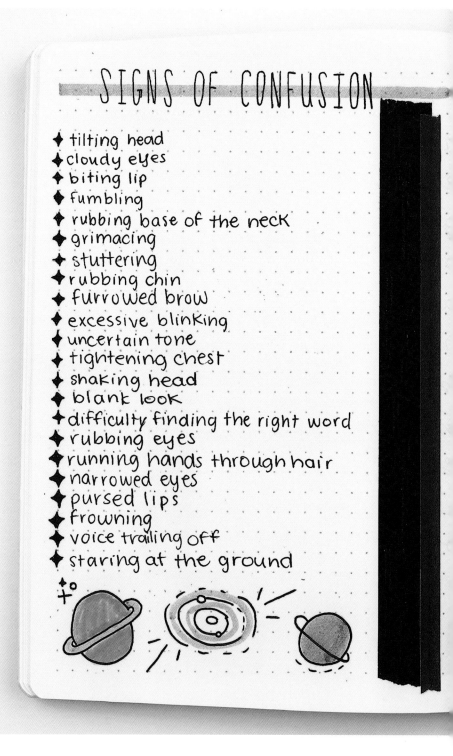

A sample layout by Alyssa that inventories ideas for developing and presenting a fictional character.

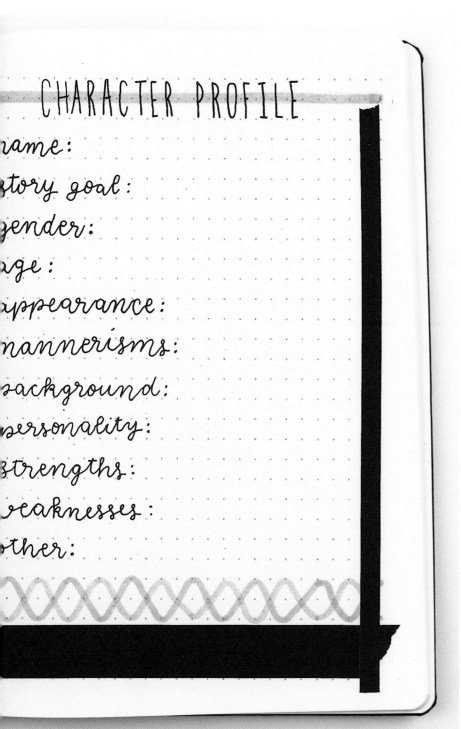

CHARACTER PROFILE

name:

story goal:

gender:

age:

appearance:

mannerisms:

background:

personality:

strengths:

weaknesses:

other:

You can also use your bullet journal to get all your story ideas on paper. Curate a list of all the ideas that are floating around in your head; then, you can refer back to that list when trying to pick a project to work on. This doesn't need to be created in an organized fashion—it could merely be a brain dump to get out all of your thoughts. These ideas can come from snippets of overheard conversations, something you hear on the radio/TV, music, or anything else that inspires you.

Additionally, some school assignments have a creative component to them. I recommend spending some time to find a way to make an impact with this part of your assignment. Don't just slap something on a bristol board and turn it in. Use color, grab the teacher's attention, and let it show that you put thought into the assignment. If you can't come up with ideas, ask an art teacher or older students for advice. You can also ask your teacher to see a creative assignment from a past student, as they typically keep a few.

HISTORY

● ● ● Studying history can be a daunting task—there's just so much to know! Here are some methods to take notes on important information.

Timelines

Making a timeline of a period you're studying guides you in reviewing the important events and putting them in context with one another.

1. The first step is to draw the timeline. A grid or dot-grid notebook will facilitate this process by allowing you to count squares and divide the timeline evenly. If you're not using one of those notebook types, use a ruler to measure precise intervals and draw a straight line.

2. Next, brainstorm a list of the important events in the time period and write a short description of each. Start by only writing down the information you can recall from memory to test your knowledge and identify your areas of weakness.

3. After you've written everything you remember, read through your textbook and notes to fill in the information you've missed. You can determine which events and details are important by skimming your textbook for headings, subheadings, and bolded words. Generally, the most important information will be emphasized by these formatting distinctions. You can also refer to resources such as prep books or review videos, in which experts boil down the material to the bare essentials.

Here are some details you might consider including on your timeline:

- Location
- Key details
- Important people involved
- Cause-and-effect relationships
- Event type (political, religious, artistic, economic, etc.)

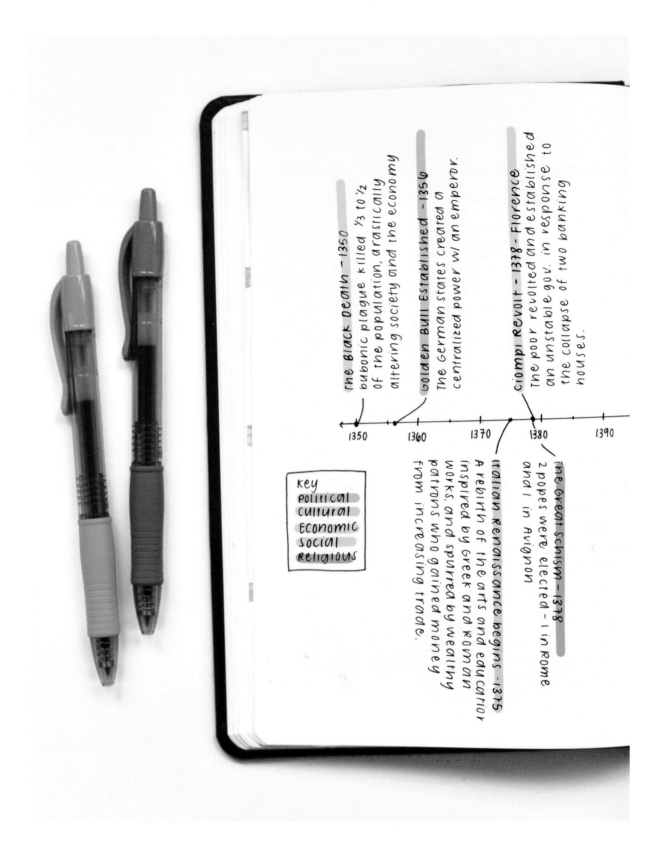

The Black Death - 1350
bubonic plague killed ⅓ to ½ of the population, drastically altering society and the economy

Golden Bull Established - 1356
The German states created a centralized power w/ an emperor.

Ciompi Revolt - 1378 - Florence
the poor revolted and established a council of two in response to the collapse of the banking houses.

```
←————•————•————|————•|——|————|————→
    1350      1360    1370    1380      1390
```

Key
political
cultural
economic
social
religious

Italian Renaissance begins - 1375
A rebirth of the arts and education inspired by Greek and Roman works, and spurred by wealthy patrons who gained money from increasing trade.

The Great Schism - 1378
2 popes were elected - 1 in Rome and 1 in Avignon

A color-coded timeline by Jasmine that combines political, cultural, economic, social, and religious events for the early Renaissance in Europe.

Key Historical Figures

Certain people tend to show up again and again in history; these figures are involved in many important events and have a large influence throughout their lifetimes. You can create a concise reference guide to these key people in your bullet journal.

When you start a new chapter or unit, skim through your class materials and create a preliminary list of important people. Key figures include all types of people, ranging from notorious political leaders to famous artists. Then, set up a spread with a section allotted to each person. As you progress through the chapter, learning about people and events through readings or lectures, add new details to your spread.

The information you add will vary greatly depending on each figure's role in history. For instance, you would record the most consequential policies of a political leader or the most famous works of an artist. Here are some details you might want to look out for:

- Years of birth and death
- Involvement in important events
- Key biographical details
- Political parties, ideas, and viewpoints
- Influence on other events and people

By the end of the unit, you'll have created a concise reference guide for the historical figures you need to know.

Study Tip

You can use this guide as a set of flashcards by covering up the details and trying to recall them.

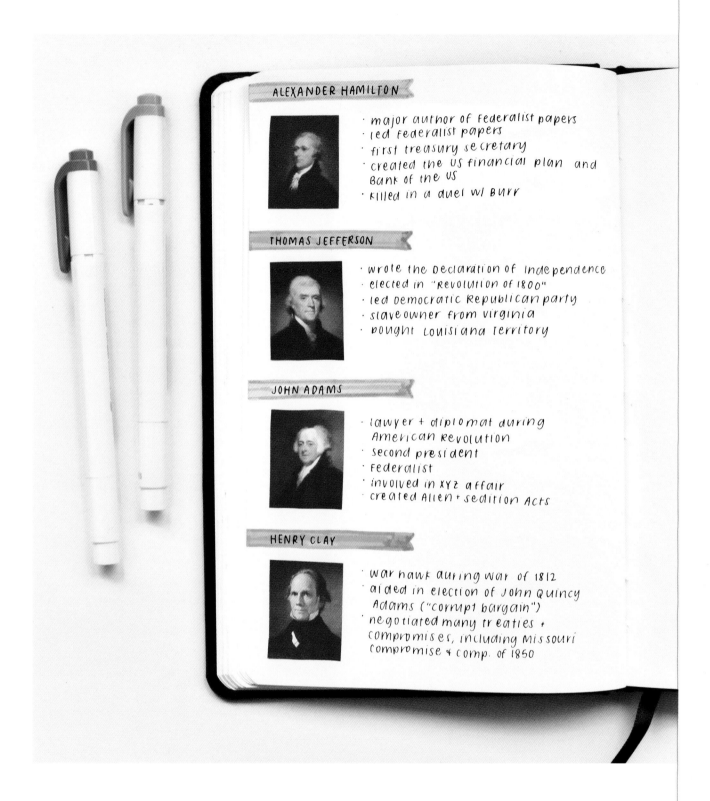

ALEXANDER HAMILTON

- major author of Federalist papers
- led Federalist papers
- first treasury secretary
- created the US financial plan and Bank of the US
- killed in a duel w/ Burr

THOMAS JEFFERSON

- wrote the Declaration of Independence
- elected in "Revolution of 1800"
- led Democratic Republican party
- slaveowner from Virginia
- bought Louisiana Territory

JOHN ADAMS

- lawyer + diplomat during American Revolution
- second president
- Federalist
- involved in XYZ affair
- created Alien + Sedition Acts

HENRY CLAY

- war hawk during War of 1812
- aided in election of John Quincy Adams ("corrupt bargain")
- negotiated many treaties + compromises, including Missouri Compromise & comp. of 1850

A layout by Jasmine of key historical figures that summarizes important dates and events, professional accomplishments, and political affiliation for each.

Geography & Maps

Let's be realistic—drawing a map by hand in your bullet journal is almost impossible. Accuracy is paramount when it comes to geography, so an approximate freehand sketch or traced drawing just won't cut it. For this reason, I would instead recommend that you print out a simple map and paste it into your journal.

The next step is to fill in your map. Refer to any resources your teacher has given you to make a list of the cities, countries, landforms, bodies of water, and any other geographic features you'll need to know. Then, use an atlas or the Internet to locate and label them on your reference map.

Be sure to create a key, with symbols and colors that tell you what type of feature each label represents.

By doing this, you gain knowledge of the material by searching for the information and create an all-in-one reference to use as a study tool.

Study Tips

One option for studying from a map in your bullet journal is to label everything in your journal and then cut up sticky notes into small pieces to cover all of the names. After quizzing yourself on what each label should be, you can remove the sticky notes to check your answers.

A second option is to put the location names on sticky notes rather than permanently labeling them in your journal. First, use outside reference materials to correctly place the labels in the right location. Take a picture of the correct arrangement to use as your answer key. Then, remove all of the labels and shuffle them around—your challenge is to place the labels in their correct locations Check your answers against the photo you took and then mark the labels you struggled with to study again.

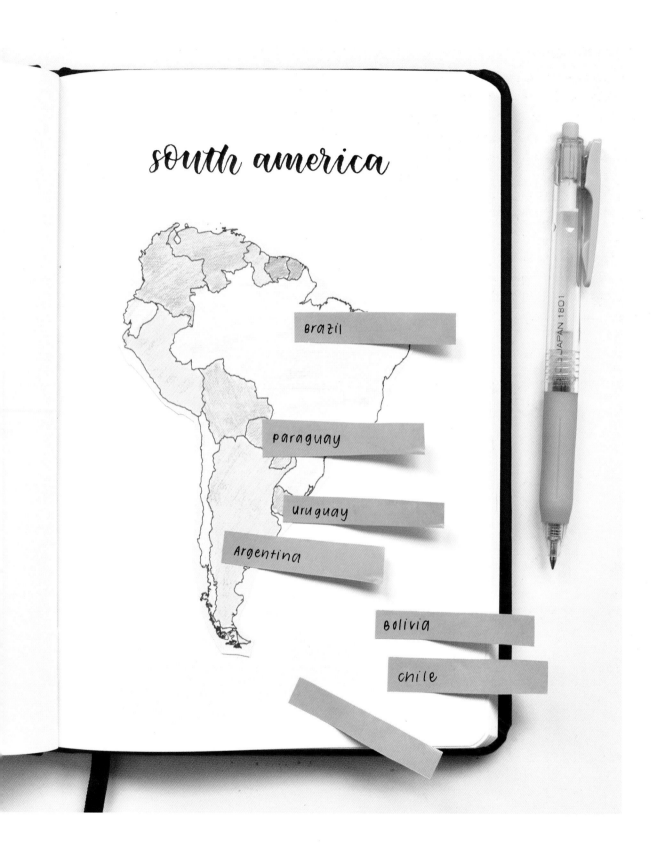

south america

Brazil

paraguay

uruguay

Argentina

Bolivia

chile

A geography study tool by Jasmine: Print out, cut out, and color a simple map, make removable ID labels for each country, and create an answer key.

ECONOMICS

● ● ● There are two branches of economics: macroeconomics and microeconomics. This section contains strategies for taking notes on both. Studying economics requires you to understand many concepts, new terminology, graphs, and some mathematical calculations. A bullet journal is an ideal tool for keeping track of these and having them in one place for review.

A quick-review economics graph by Alyssa that summarizes cost curves.

The following are a few ways you can use your bullet journal to save time and learn more efficiently:

- List key terms with definitions. This is a great time saver, as you can refer back to the list as needed and find the information quickly.
- Explain important concepts with labeled diagrams to solidify understanding.
- Use flow charts and diagrams to show how various factors affect the flow of money between businesses and households.
- Use tables to compare different concepts and systems, such as capitalism and socialism.
- Draw and label graphs in economics terms.
- Sketch graphs with factors that affect the curve. This is perfect for quick review.
- Write out mathematical formulas, defining each term and including a sample solution.
- Make a list of online resources that are helpful or that you want to review to supplement your assigned reading.

I often look at my bullet journal before a test to get a quick snapshot of important concepts, see how a graph or curve should look, refer to an image summarizing an important concept, and so on. I find it much easier than going through my books with all of my notes and homework.

Study Tip

There is a wide array of videos about economics available online. I would recommend using your bullet journal to make a list of videos that you want to view, in the order you want to view them. After watching each video, you can check it off on your list and give it a usefulness rating. This way you aren't wasting time figuring out where you left off and what videos are worth watching again if you need reinforcement of the material.

EARTH SCIENCES

● ● ● The earth sciences, including geology, oceanography, and meteorology, require memorization of many definitions and facts. In these subjects, facts are often related to each other through diagrams of certain processes or features.

These three types of knowledge—definitions, facts, and diagrams—can be combined and condensed. The first step is to draw your diagram. This can seem challenging, especially if you aren't artistically inclined, but it becomes fairly simple once you break it down into manageable steps.

In this example setup, I'll be creating a diagram about the layers of the earth's atmosphere.

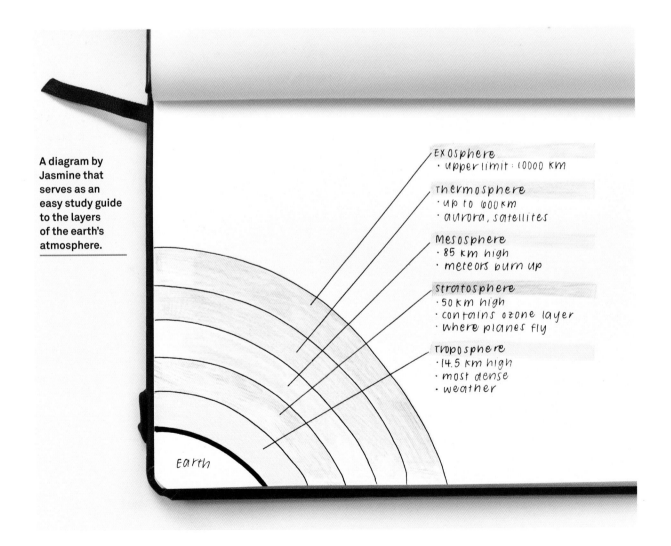

A diagram by Jasmine that serves as an easy study guide to the layers of the earth's atmosphere.

1 | Find a Good Reference Image

You'll need to find a diagram that includes all of the necessary information, whether it comes from your textbook or the Internet. If possible, choose a diagram with a simple, easy-to-replicate art style. A simple line drawing will be easier to copy than a complex drawing with three-dimensional perspective.

2 | Sketch the Major Shapes

For now, don't worry about capturing the details. Look at the reference image as if you were looking from far away and see the major shapes of the drawing—a rectangle there, a circle there. Sketch these with a pencil, in approximately the correct shape, size, and position.

3 | Refine & Repeat

Now, add a few more details to your basic shapes. Maybe that edge of the triangle has a slight curve, or there's a zigzag on the top of the circle. Add details bit by bit to refine the shape and get closer and closer to the reference image. Take as much time and as many attempts as you need.

4 | Trace in Pen

Once your pencil sketch is accurate, trace your final sketch with a pen. Don't worry if you make small errors—you can cover them with correction-fluid or a white pen. Check the tips and tricks section on page 22 for more advice on correcting mistakes.

5 | Color

One option is to use colors that are true to how the subject looks in real life. You could also color each distinct part of the diagram with a different color, such as coloring the troposphere green and the stratosphere red. This allows you to visually separate different parts, making it clearer where each starts and ends.

6 | Add Labels

Once you've drawn and colored all parts, it's time to label them. I recommend putting all the labels on one side of the page rather than directly on the picture. This way, you can cover them up with a sheet of paper to quiz yourself, using the diagram as a giant flashcard.

Be sure to leave some space to jot down notes underneath each label. You can add a definition and key details for each part of the diagram. In my example, I wrote the key facts about each layer of the atmosphere underneath each label. By doing so, the diagram becomes a complete reference—you haven't just recorded the location of each part but also key facts and definitions.

ENVIRONMENTAL SCIENCE

● ● ● An important part of environmental science is keeping up with current events. There are many great sources of information available online, and you can use your bullet journal to make a list of specific websites to visit and to track whether you reviewed the content. Labeled diagrams are a great visual aid that can simplify the understanding of a complex process. A flow chart is a useful tool to summarize the events that led to a specific event. A pie chart is a quick snapshot that makes memorization of certain facts easier—for example, the factors causing air pollution. It's important to have quick, easy access to these tools so that you can use your time efficiently and shorten your study time.

Here are some ways to use lists in your environmental science studying:

- Make a list of all the parts of your class curriculum that you need to study. The more comprehensive the list, the more prepared you'll be for your exam. You can use this list to track your progress of completed topics.
- There's an overwhelming amount of information available online, and it can be a huge waste of time to hop from site to site trying to find accurate, trustworthy information. It's more efficient to curate a list of specific reliable websites you can go to, such as NASA, National Geographic, and sites for specific news shows and newspapers.
- Make a list of TED Talks that deal with subjects you want to learn more about. You can check them off as you view them and give a rating of usefulness.

- Make a list of key words. Environmental science involves a lot of new vocabulary, so it will be necessary to make a list of important words and define them.
- Make a list of infographic articles— articles with written and visual representation of information. This is another way of acquiring information in a more interesting graphical form. You can check these off when you've viewed the information.
- Make a list of social media sites that you find interesting, such as environmental-themed bloggers, Pinterest boards, and Twitter and Instagram accounts. You may not want to follow all of them, but keeping a list in your bullet journal lets you remember them and visit them as needed.
- Make a list of mnemonics to help memorize details, such as HIPPO—Habitat Loss, Invasive Species, Pollution, Human Population, and Overharvesting, all threats to biodiversity.

ENVIRONMENTAL SCIENCE

relationship between photosynthesis and cellular respiration:

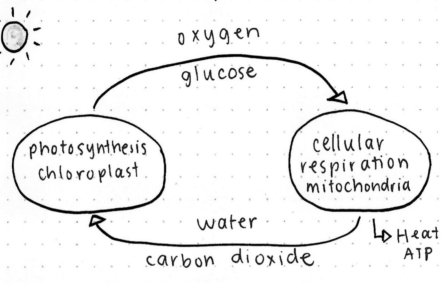

cellular respiration : $C_6H_{12}O_6 + 6O_2 \rightarrow 6CO_2 + 6H_2O + heat + energy (ATP)$

photosynthesis : $6CO_2 + 6H_2O \rightarrow C_6H_{12}O_6 + 6O_2$
light energy (sun)

This layout by Alyssa summarizes the relationship between photosynthesis and cellular respiration by combining a simple diagram with essential formulas.

BIOLOGY

● ● ● Biology has a large amount of information to be learned, and there's a fair amount of memorization involved. You have to understand the concepts, of course, but there are a lot of new words and processes to memorize.

You may be wondering why you should write out these lists and draw these diagrams in your bullet journal when you have them in your class notes or textbook. Repetition is key to committing large amounts of data to your memory. Also, having all of these lists/diagrams in one accessible place without having to look through copious amounts of notes will help you to find the information easily and quickly, thereby eliminating some of the many excuses for procrastination. Why write this information and not type it out? When you write, more of your brain gets involved, and you remember more of the information.

Tips for Doing Well in Biology

Here are some habits you can implement in your bullet journal to help improve your understanding of biology—and, as a result, your grade.

Before class:

- Do a quick overview of textbook pages and write out a list of bolded words from the textbook in your bullet journal. Make sure you understand the ideas behind those words.
- Take a close look at diagrams from the readings. Visual representations of concepts offer an alternative way of understanding the material.

During and after class:

- Add headers to the notes in your bullet journal and highlight key words and/or concepts. Make doodles to help reinforce certain ideas.
- Draw labeled diagrams of important processes with notes that aid your understanding.
- Make tables to compare and contrast concepts.
- Write out important processes in your own words.

List-making is a very important tool for biology. The following are some types of lists that will be very helpful when studying biology:

- A list of key words (terminology)
- A list of important words with definition so that you can easily refer back to them
- A legend of symbols and abbreviations to assist your note-taking in class and keep it updated
- A list of mnemonic devices to help you remember the order of steps in important processes (for example, IPMAT—Interphase, Prophase, Metaphase, Anaphase, and Telophase—the stages for mitosis)
- A list of websites with useful diagrams, videos, Quizlets, flashcards, and other resources that help illuminate concepts for you

homeostasis

negative feedback loop
↳ used to maintain the human body
 in a steady state

example:

event	→	body temperature rises
action	→	vasodilation
effect	→	body begins to sweat
result	→	normal body temperature

A biology layout by Alyssa that presents the process of homeostasis in a straightforward way.

CHEMISTRY

● ● ● The note-taking tips and techniques covered in other sections are applicable to chemistry, too. You can learn about organizing formulas in the trigonometry section (page 40), taking notes on example problems in the calculus section (page 46), and organizing formulas side by side with examples in the physics section (page 76).

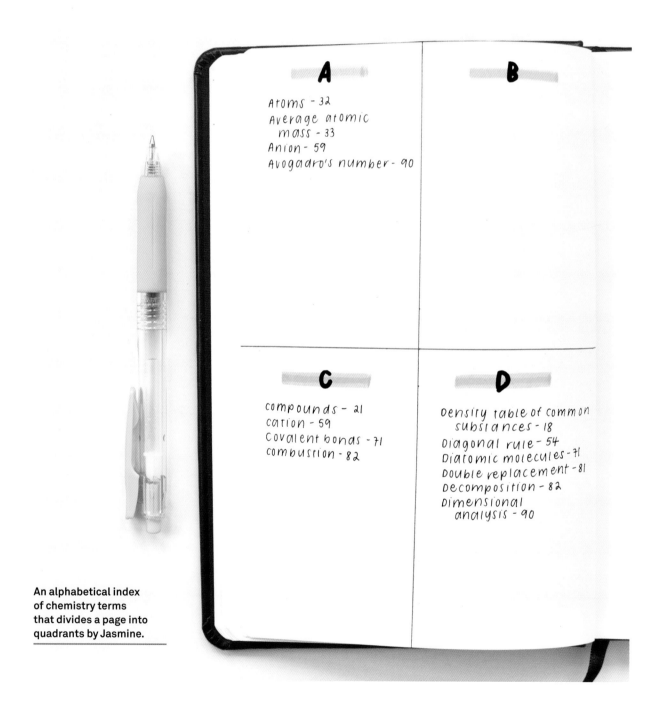

A

Atoms - 32
Average atomic
 mass - 33
Anion - 59
Avogadro's number - 90

B

C

compounds - 21
cation - 59
Covalent bonds - 71
combustion - 82

D

Density table of common
 substances - 18
Diagonal rule - 54
Diatomic molecules - 71
Double replacement - 81
Decomposition - 82
Dimensional
 analysis - 90

An alphabetical index of chemistry terms that divides a page into quadrants by Jasmine.

In chemistry, there's so much you need to remember! Being able to find a certain definition or fact in your notes can be challenging because of the wide range of information. One solution to this is creating an index for your notes. In this case, we don't mean an index in the bullet journal sense, synonymous with a table of contents—rather, this would be something similar to the alphabetical list of topics and page numbers found at the end of an academic book.

To set up your index, start by dividing your pages into sections for each letter. In my example, I used six pages with four letters on each page.

You'll also need to add page numbers to your notebook. Check the Tips & Tricks on page 22 for advice on setting up page numbers.

Now, just add the topics to your index as you learn them. If you're setting up the index after you've already started taking notes, this is an opportunity to review the information you've learned. Skimming through your notes, you'll get a quick refresher on previous topics.

For each index entry, write the topic and the page number where it is located. A topic may show up on multiple pages; for these duplicate topics, add the page number to the existing entry instead of making a new entry.

Here are some topics that you'll want to include in your index:

- The main subject of a lecture or chapter
- Important vocabulary words
- Formulas you'll want to reference

Remember that you are not writing the formula or the definition in the index. Rather, you're just noting the location of the information so you can easily find when you need it.

Don't worry about alphabetizing within each letter—it's almost impossible to do, and skimming all of the words within a letter category doesn't take much more time than searching in an alphabetical list.

PHYSICS

● ● ● Physics blurs the line between science and math. The subject requires not only memorization of facts and formulas but also learning when and how to apply them to problems.

Effective Note-Taking for Formulas

Copying down formulas is simple, but knowing how and when to use them is a challenge. Effective notes can be a clear guide on how and when to use a certain formula. Your notes need to show what each variable represents so you know which numbers to plug in for each and what information you can find. Color-coding with colorful pens, highlighters, or markers can make this easy to understand.

First, write the formula, using a different color for each variable. Then, in the corresponding color, write what each variable represents and the units used. For example, you might choose to use green for velocity (in m/s) and purple for electric current (in amperes). As you add more and more formulas to your reference pages, try to be consistent with your color use throughout all formulas.

Knowing exactly what information to use with a formula will make it easier to recognize which formulas to apply in a given situation. When solving a problem, identify the information you already have and what information you need to find and then look for formulas that match these.

Organizing Examples with Formulas

You can also take notes on formulas alongside example problems to show what types of problems use that formula. Start by setting up two columns in your notebook: one for the question and work, and another for the formulas.

In the first column, copy down the question text and work. In the other, copy down the formula, in line with the step when it is used. Use the previously discussed color-coding method when copying down the formula. Then, whenever information that you will plug into the formula shows up in the question text or your work, highlight or circle it with the corresponding color. The continued use of the color code will make it clear exactly which numbers are being used in the formula and which variables they are being substituted for.

This method can be combined with the two-column method discussed in the Calculus section (page 46), which includes a written explanation of what steps are being taken and why. You could use three separate columns for work, formulas, and steps, or you could combine formulas and steps in the same column.

Newton's Law of Universal Gravitation

$$F = G \frac{m_1 m_2}{r^2}$$

Force
in Newtons

mass
of object 1

mass
of object 2

universal
gravitational
constant
6.673×10^{-11}

distance
between centers of the 2
objects in meters

Determine the
force of gravitational attraction
between the earth
$(m = 5.98 \times 10^{24}$ kg$)$ and a
70 kg
physics student if the student
is standing at sea level,
6.38×10^6 m from Earth's center.

$$F = \frac{(6.673 \times 10^{-11})(5.98 \times 10^{24} \text{ kg})(70 \text{ kg})}{(6.38 \times 10^6)^2}$$

$$F = 686 \text{ N}$$

$$F = G \frac{m_1 m_2}{r^2}$$

ONLINE COURSES

● ● ● Some people think doing a course online is much easier that completing it in person, but there are many challenges with doing an online course that you usually don't experience in class. For example, there are fewer deadlines, and in some cases, there's no authority figure telling you to do your work at a certain time. Some people may find certain aspects of an online course to be great because you can work at your own pace and when you're in a productive frame of mind. However, there are drawbacks also—you have to be accountable, disciplined, and able to work independently.

There are generally two types of online courses: one has assignments and deadlines, and the other is a more open type of course with only a final deadline by which you have to complete the entire course. With the latter type, it's very easy to prioritize other things over the online course because there are no interim deadlines for any of the content. Your bullet journal is a great tool to organize your progress. Online courses may have a four- or twelve-month deadline, but you're generally allowed to complete them faster.

The first step is to set self-imposed deadlines in your bullet journal. A good way to estimate how much time you should allot to complete a unit of the course is to look at your school schedule and see how long it takes to complete a unit in an in-person class. Take your course outline and figure out how many units there are. If it takes one month to complete a unit at school, then allow yourself one month on your self-imposed schedule to complete each unit of your online course. Next, look at each unit to see what assignments and tests there are within that unit and set additional deadlines in your one-month timeframe for that unit. At the end of this process, you should have a list in your bullet journal with dates to complete each assignment, test, and unit.

The next step is to look at your weekly layout and block off time to work on your online course. Keep in mind how much time you usually spend in class and doing homework for an in-person course and schedule a similar amount of time for your online course. Of course, you can customise your schedule and assign less online work during busy times and more during free time. Remember that your bullet journal can be fully customizable to make the best use of your schedule.

online course schedule

NAME	DATE
assignment # 1	sept 14
discussion	sept 18
assignment # 2	sept 25
unit test	sept 30
unit one reflection	sept 30
assignment # 3	oct 7
assignment # 4	oct 16
quiz	oct 18
video discussion	oct 22
assignment # 5	oct 25
project	oct 27
unit test	oct 31
unit two reflection	oct 31

An example by Alyssa of how to block out time for an online class based on upcoming assignments, tests/quizzes, and discussions.

MUSIC, ARTS & OTHER ELECTIVES ...

Planning Your Music Practice

Practice makes perfect! Whether you're part of the school choir or learning an instrument on your own, practice is key to honing your craft. Here are some tips for setting up your practice schedule.

An easy approach to tracking progress for learning songs by Jasmine.

song progress

title	sight read	sing w/ solfege	learn words	memorize
The Impossible Quest	●	●	●	○
Kruhay	●	●	●	●
Water Beetle	●	○	○	○
From Now On	○	○	○	○

Track Your Progress on Each Piece

In your bullet journal, you can log your progress on each piece you're working on. The steps involved will vary based on your instrument. For example, learning a choir song would include sight-reading, singing with solfège, singing with words, and memorizing.

The tracker setup is like a grid of checkboxes. Set up a table with one column for the names of the pieces and another column for the steps in the learning process. For each song, each step will have a checkbox. This set up shows you what to work on next and gives you a visual progress bar for each song.

Schedule Your Time

Sometimes, it just feels like there aren't enough hours in a day for practice! To make sure you have enough, add practice time to your schedule as if it were an appointment. For instance, you might reserve 7:00 to 8:00 p.m. Don't let anything else take over this time period—it's an appointment with yourself.

If you have trouble keeping to a personal schedule, set up an appointment with someone else. Tell your parents or friends that you'll be practicing at a certain time, and ask them to check in on you. This creates outward accountability, forcing you to respect the schedule.

Concert Planning

Add all of your performance dates to your planner setups, including your yearly and monthly calendars.

As the performance approaches and you know more about which pieces you'll perform, create a practice schedule. A concert is like an exam, requiring a similar degree of preparation, so the planning process is similar, too. The exam prep process described on page 34 can also be applied to performance planning.

As you find more details about a concert, such as the location, dress code, call time, and stage rehearsal or sound check times, be sure to note the information in your bullet journal. You can use note bullets underneath the performance event bullet.

Brainstorming Art Pieces

Ideas for art pieces can come from random bursts of inspiration or long brainstorming sessions. Inspiration is what drives creativity, but regardless of where your ideas arise, they only retain their value if you can remember them. A bullet journal is a perfect place to preserve ideas and inspiration.

How to Capture Ideas

For most visual art forms, a small thumbnail sketch can effectively capture a concept on paper. Next to each thumbnail, leave space for notes about media, colors, textures, and any other details.

It can be especially difficult to sketch the concept you're envisioning when working with multidimensional art forms, such as sculpture or video. In these cases, be sure to use multiple thumbnails to capture multiple perspectives or scenes and write lots of notes.

Inspiration Collages

Inspiration can come from anywhere—an advertisement online, a mural you see on the street, or a flyer you pick up at school. When you find something interesting and inspiring, take a photo or keep a physical copy to paste in your bullet journal.

I recommend using washi tape, which you can peel off later without ripping the paper underneath. This way, you can remove pieces that no longer interest you. This also allows you to rearrange a page to see different and potentially inspiring interactions between images.

Dealing with Deadlines: Yearbook, Journalism & Other Electives

Electives centered on a large project, like yearbook and journalism, present a significant organizational challenge. Since you have so much work to accomplish over a long time period, there are many opportunities to procrastinate and fall behind. Here are a few tips and tricks for keeping yourself and other staff members on track, based on my experience as a yearbook editor.

Create a Checklist Grid

A checklist grid is essentially a table of checkboxes, similar to the progress tracker described on page 80. The column on the far right will list each large task that needs to be completed—in my yearbook example, each spread in the book is a list item. Write the smaller tasks that make up the larger task along the top as headers for each column of checkboxes. Here, each spread requires tasks such as creating a template, taking photos, and interviewing students.

Create a Responsibilities List

For each task on the checklist grid, write down the individual staff member who is ultimately responsible for completing the work. Assigning a task to a vague category of people, such as "sophomores" or "all staff members," can cause everyone to think, "That's not my job; someone else will handle it"—meaning no one ends up doing it. Assigning a task to a specific individual will make responsibilities clear, ensuring that every staff member knows exactly what their objectives are and that every task is taken care of.

Set Interim Deadlines

When a final deadline is months away, it's easy to lose sight of what needs to be done in the meantime. The due date seems so distant that it feels like there's plenty of time and it would okay to procrastinate right now. To counteract this, pace yourself and other staff members by setting up unofficial deadlines before the official deadlines given by print companies. For example, you might unofficially have twenty pages due per month to pace yourselves to turn in sixty pages on the official deadline.

HEALTH & FITNESS

● ● ● Even though academics are the main focus of student life, taking care of your physical health is just as important. Physical fitness doesn't just benefit your body—it also improves your mental well-being. Exercising and eating regularly will increase your mental energy levels and reduce stress.

This section will aid you in planning and organizing your life, rather than giving concrete meal or fitness tips. See a nutritionist, doctor, or other expert for health advice.

Meal Planning

Planning out your meals will encourage you to eat healthier foods. By committing yourself to nutritious meals on paper, you're more likely to follow through and actually eat those healthy meals. Also, if you've already decided what to eat, you're less likely to buy unhealthy food on a whim.

Weekly and daily planners are the ideal locations for meal planning in your bullet journal. A weekly plan is especially useful for grocery shopping—you can make your grocery list based on the meals you plan to cook that week.

Going a step further, you can also make your meals in advance in accordance with your plan. This makes it even easier for you to eat healthy food during the week. If you ever felt that you had to buy prepackaged, less-healthy food because you didn't have time to cook, making your meals ahead of time can remove this obstacle.

Food Tracking

If you don't make your own food, a food tracker can improve your nutrition. Behavior changes when you observe it—when you keep track of everything you eat, you're more conscious of your choices. You can notice unhealthy patterns in your eating habits, such as consistently drinking an unhealthy coffee drink or eating too many snacks late at night. Awareness is the first step in making a positive change.

The goal of a food tracker is not to count calories and restrict what you are eating. Rather, the aim is simply to make you more mindful of what foods you're fueling your body with, subtly nudging you towards more nutritious options.

Like a meal planner, a food tracker is best used as part of a weekly or daily setup. You can also set it up side by side with a meal planner, which allows you to compare your plans and actual results. Once again, awareness of where you may be deviating from your plan is the first step in improving your results.

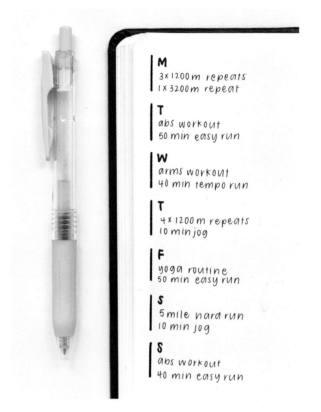

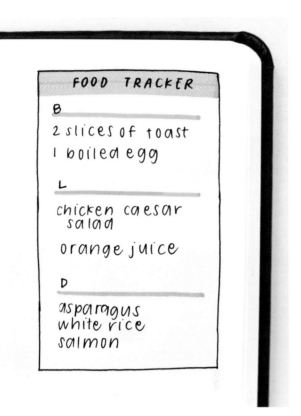

Sample layouts for tracking food daily and planning workouts over the course of a week, both by Jasmine.

Workout Planning

Getting enough exercise can make a huge difference in your stress levels! There's no getting around the fact that working out is usually uncomfortable, but simply setting up a plan can significantly reduce your resistance to doing certain activities. Having a clear path will remove the mental roadblock of not knowing what to do, decreasing the chances that you'll just choose to skip the workout instead.

Creating Workouts

The first step in creating an exercise plan is creating workouts. There's an endless world of options, including Pilates, yoga, dumbbells, weight machines, running, and more. You don't necessarily have to make your plans yourself—you can find premade workout sequences or video guides online. Before making or choosing a workout, do plenty of research to make sure it will be both safe and effective. Check with a doctor for advice on starting your own exercise regimen based on your current health.

Planning Workouts

Now that you've got a list of workout options, you need to schedule them. Your workout schedule can be a separate module in your monthly, weekly, or daily planners, or you can add your workouts as task bullets. Your workout plan will vary based on your goals and your level of fitness. My example shows my cross-country workout schedule, based on plans created by my school's cross-country coach.

GROWING WITH GOALS

● ● ● In order to grow, you need to set goals and reflect on those goals. You can do this easily using your bullet journal. A commonly used and effective way of setting goals is to use the SMART acronym. You would create goals that meet the following criteria:

- **S:** Specific—what exactly is your goal?
- **M:** Measurable—how will you know you have achieved your goal?
- **A:** Attainable—is this a realistic goal?
- **R**: Relevant—is this truly important to you at this point in your life?
- **T:** Time-bound—what is your deadline to achieve this goal?

These criteria are important, as detailed, specific goals are much easier to reach than lofty ones you have no plan in place to actually reach. Also, keep in mind that there is a difference between goals and aspirations. The "A" of the SMART acronym explains this: a goal is attainable. An aspiration or dream isn't something you can control, whereas a goal is within your control. There are several ways in which you can set goals for yourself using your bullet journal.

Goal Setting

When you set up your bullet journal, you can set goals for your year or for whatever time period you choose. One option is to do this categorically. Examples of categories you can use to divide your goals are personal, health and fitness, finance, education and career, travel, spirituality, and relationships. I would recommend choosing three to five categories that are most important to you, keeping in mind that balance in life is essential so don't forget to have some fun goals in there too.

You can also set goals by priority, dividing them into high- and low-priority goals. This type of goal setting is perfect for people who have been wanting to reach a certain goal for a while but always find something is stopping them. Through setting your goals in terms of priorities, you know which are of great importance to your life. I know that, personally, I have struggled with having too many goals, and I end up spending my time on things that don't mean that much to me when I could be focussing on high priority goals.

Additionally, you can set your goals in terms of short term and long term. This is great if you know you have goals you want to get to right away, such as specific health-related goals to improve your well-being versus long term career goals. Feel free to combine these types of goal setting as well.

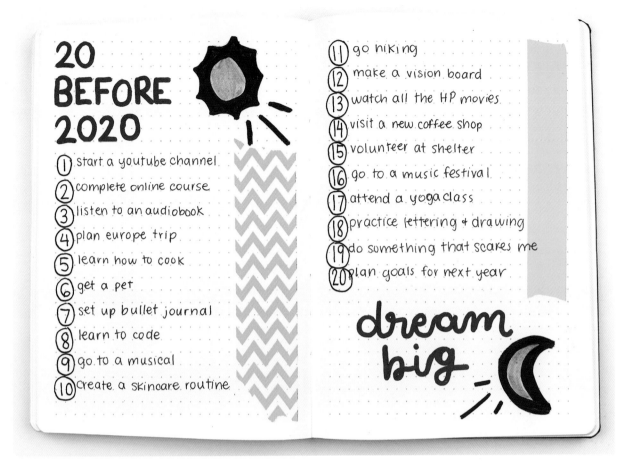

20 BEFORE 2020

1. start a youtube channel
2. complete online course
3. listen to an audiobook
4. plan europe trip
5. learn how to cook
6. get a pet
7. set up bullet journal
8. learn to code
9. go to a musical
10. create a skincare routine
11. go hiking
12. make a vision board
13. watch all the HP movies
14. visit a new coffee shop
15. volunteer at shelter
16. go to a music festival
17. attend a yoga class
18. practice lettering & drawing
19. do something that scares me
20. plan goals for next year

dream big

A list of long-term
personal goals
by Alyssa.

If you set goals on a yearly basis, I recommend checking in with them every month in a monthly reflection (see page 92 for more details). This will help you hold yourself accountable to your goals and achieve more. It will also actively remind you of each goal and its importance to you.

If this type of in-depth goal setting isn't your style, you might prefer some quick and easy goal setting—for example, creating a list of twenty things you want to do before 2020, or whatever year you're planning for. This is a fun and simple way to set goals for the year that you're excited about.

Instead of, or in addition to, yearly goals, you can set monthly goals. This can be a step further in achieving your yearly goal. Breaking down your yearly goals every month is a great way of reminding you what your priorities are and what your focus for the month is. There are two main methods of doing this.

Monthly Cover Page

A monthly cover page is a spread you can create for the beginning of each month, stating what month it is and including some doodles or whatever else you would like there. This option would be best if you're doing monthly goals in addition to your yearly goals, as there is limited space and this is a brief overview. I personally like to add in lots of doodles and motivational quotes relating to my goals, which inspire me. Sometimes, I will even include a small collage of photos.

Flow Chart

This is an in-depth look at achieving specific goals. A flow chart is a detailed action plan for what you need to get done in a given month to achieve your overarching goal.

Goal Tracking

In addition to monthly goal setting, you can use habit trackers to focus on your priorities. Habit trackers are quite self-explanatory—they are methods of tracking your habits. This is a great way to check in on your habits on a daily basis. For example, if you have a health-related yearly goal with a focus on your diet in your monthly goals, then in your habit tracker, you can track every day you eat only healthy food. This will hold you accountable and refer back to the priorities you set at the beginning of your goal process.

When I originally began using habit trackers, I thought they were useless, and I didn't follow through with them. However, this was because I was tracking habits that I didn't really care about; I was tracking them because I thought I should. Once I focused on my own priorities and aligned my habit trackers with those priorities, I enjoyed the sense of accomplishment I felt when I could fill in each little colored square. It was exciting to see my progress because I cared about what I was tracking. Also, when your habit tracker is an accurate and relevant reflection of your goal, you're consciously working on your goal every day, and this will result in great progress toward that goal.

Examples of habits you might track include the following:

- Water consumption
- Exercise
- Reading
- Sleeping
- Journaling
- Homework assignments

GOAL: *health*

PURPOSE

- lower stress
- overall well-being
- happiness

OBSTACLES

- time consuming
- motivation
- laziness
- excuses

ACTION PLAN

- workout in mornings
- buy healthier snacks
- learn new recipes
- sleep more
- remember reusable water bottle

Some health goals and ways to achieve them, by Alyssa.

PERSONAL JOURNALING

● ● ● A bullet journal is an essential tool for all aspects of life—it's a companion for planning, organization, and studying, and it's valuable for personal journaling as well. Journaling can help you process your thoughts and reflect and improve on past actions. In this section, we'll give some tips and ideas about personal journaling.

Gratitude Journaling

As students, we have a lot of stress in our lives, and it's sometimes hard to see past the negative aspects. Numerous studies have shown that gratitude journaling can increase happiness. Making a conscious effort to think about what you're grateful for refocuses your thoughts on the positive side of life. Additionally, living in search of moments of gratitude will make the good parts of each day more salient. When you focus on the positive parts of life as you live it, they become the main focus of your thoughts and memories.

When you're journaling, also reflect on why you're grateful for each thing you list. Articulating your thoughts allows you to reflect on why certain things matter to you, deepening your gratitude for each.

Here are a couple of ideas for recording what you're grateful for.

One Line a Day

Each day, write an entry for something you experienced that day. This could be a "365 days of gratitude" layout for the entire year, or you can incorporate a gratitude log into each monthly, weekly, or daily setup.

You don't necessarily have to do one entry every day, either—journaling a few times a week, weekly, or even less often can be just as valuable. The main objective of this technique is creating a regular routine of journaling.

Drawing or Doodling

Rather than just writing down a description of what you are grateful for, create a small drawing or doodle that represents it. This technique has the additional benefit of helping you de-stress through doodling.

Goals in Review

Setting an effective goal is the ideal first step toward reaching it—you can't hit a target if you don't even know where it is. Regularly reflecting on your goals is also essential, motivating you by constantly reminding you of your objective and why you wanted to accomplish it in the first place. You'll also identify any wrong steps you may be taking and constantly nudge yourself back onto the right path.

You can find more information about goal setting on page 86. Be sure to record your goal in your journal so you know exactly what you're striving to achieve.

Next, set up a journaling spread for your goal reflections or allocate a section of your monthly, weekly, or daily planners for goal reflection.

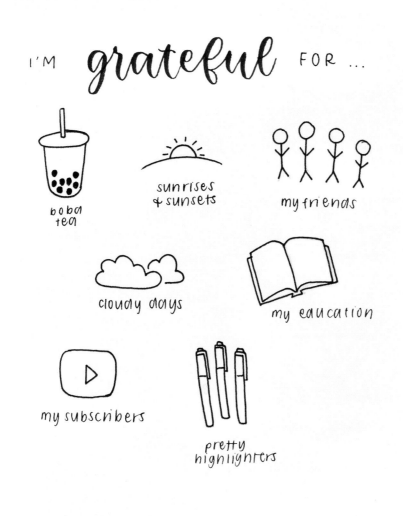

An illustrated gratitude page by Jasmine.

I personally recommend completing a goal reflection at least once a month, but no more than twice a week. Here are some questions you might want to ask yourself:

- Why do I want to achieve this goal?
- How have I worked to accomplish this goal in the past week? (Or two weeks, month, etc.)
- What are my next steps?
- What can I do differently to improve my results?

For more on goal reflections, see page 96.

Reflecting on Your Goals

I use my bullet journal to reflect on the goals I've set for myself and how I'm feeling about them. I do this on a monthly basis, but you can do it every week, or twice a month— whatever works for you.

Taking time to reflect on my goals lets me start each new month with a clean slate. If you had a rough month, getting everything down on paper is a great way to leave that in the past. If you had an amazing month, journaling about it can invigorate you for the next one.

There are two main approaches to personal journaling:

- **Structured with prompts.** This is perfect if you have no idea where to begin. See the list of sample prompts at right for some ideas.
- **Free flowing.** This allows for an uninhibited flow of thoughts. You might have a set of points similar to the structured prompts or simply write about what's on your mind.

I began with the structured method and transitioned to the free-flow approach as I became more comfortable with journaling. I gradually found I no longer needed specific prompts and wanted to reach beyond them.

When I have time, I also try to incorporate fun visuals into my reflections. If I'm writing about my struggles in calculus, I might draw a notebook. Sometimes, I'll add a photo of a happy memory or create a collage.

I like to choose a quote of the month, to acknowledge something I excelled at or to provide encouragement where I need improvement. I also take the opportunity to practice my hand lettering and get a little creative.

You may feel self-conscious writing about your goals, but try doing it for a few months in a row—you'll find it does wonders for your well-being. The most important thing about journaling is allowing yourself to be vulnerable and digging deep, which is much more easily said than done. Reflecting on your goals and habits can be tough. You might see that you missed a week of working out or only reached half your goals. Accept that perfection is unattainable and that no matter how pretty a perfectly filled-in habit tracker is, you're only human. Nonetheless, don't allow yourself to miss a week of a habit and forget about it. Do better next month. Motivate yourself with a quote. Do whatever you need to do to get back in the right headspace. I know you can reach any goal you set for yourself!

Here are some sample structured prompts you can use to get yourself writing:

- Which goals did I reach? How are they contributing to my overarching goals?
- Which goals didn't I reach? Are they still important to me?
- How do I feel about this month?
- Is my journal working for me? How can I make it more effective?
- What is one positive experience I had this month? How can I bring more of that positivity into my life?
- What is one negative experience I had this month? What did I learn about myself?
- What three things am I grateful for?
- What am I looking forward to next month?

best memories:

start: stop: continue:

goodbye
2019

hello
2020

how will i make 2020 better?

word of the year:

A sample layout for reflecting on goals set for the previous year, as well as for looking ahead, by Alyssa.

BEAUTIFYING YOUR BULLET JOURNAL

Now that we've learned about the practical planning tools used in a bullet journal, we can also add some drawings and doodles. Although lettering or doodling may seem like a distraction or waste of time, adding visual interest to your journal can add a bit of joy to your planning experience. If you enjoy opening up your planner each day, you're more likely to stick to your planning system, overall improving your organization.

Additionally, taking a few minutes to relax and doodle can improve your mental and emotional well-being, and you'll be practicing your drawing and lettering skills!

This chapter covers a variety of ways to beautify your bullet journal. We'll start with handwriting and calligraphy, giving an introduction to the art of calligraphy and some inspiration for lettering styles. Next, we'll go over tips, tutorials, and ideas for doodles and other artwork.

The ideas we present in these pages are meant to be simply that: ideas, not strict guidelines. We hope our ideas can be a jumping-off point for your own creativity. Your bullet journal is your own space to express your individuality, and we hope you enjoy doing so!

DEVELOPING & IMPROVING YOUR HANDWRITING ...

Print Handwriting

It's difficult to change your handwriting style, but it's possible through frequent practice. Find an alphabet template or lengthy sample of a handwriting style from photos of beautiful handwriting on the Internet or pick a handwriting-style font. The best way to practice is to directly trace the style, but copying also works. To study for school and practice handwriting simultaneously, rewrite book passages, formulas, or definitions in the style you want to imitate. With enough training, your hand muscles will get into the habit of writing in that style.

Besides changing your handwriting style, simply taking the time to write neatly can take your to-do lists and journal entries from a jumbled mess to an Instagram-worthy journal. Make an effort to write in a consistent style and in straight lines. Lines or a dot grid can guide you, or you can use a pencil and ruler to draw guidelines in a blank notebook.

Calligraphy

Calligraphy is an art form that spans across cultures and time periods, from ancient China to medieval European monks to the bullet journal blogger of the twenty-first century. Most bullet journalers prefer modern calligraphy, a bouncy and decorative style.

Materials

Generally, a writing tool with a firmer point will be easier to work with, while a more flexible one will allow for a more expressive range of widths.

Firmest

① Pens and other faux calligraphy

② Conical tip markers

③ Pointed pen
 (on average; varies by nib)

④ Marker tip brush pens

⑤ Brushes

Most flexible

Aa Bb Cc Dd Ee
Ff Gg Hh Ii Jj Kk
Ll Mm Nn Oo Pp
Qq Rr Ss Tt Uu
Vv Ww Xx Yy Zz
1234567890

Aa Bb Cc Dd Ee
Ff Gg Hh Ii Jj Kk
Ll Mm Nn Oo Pp
Qq Rr Ss Tt Uu
Vv Ww Xx Yy Zz

(Left) Print created with a fine point marker. (Right) Modern brush script created with a marker tip brush pen. Handwriting by Jasmine.

Getting Started

The two pillars of modern calligraphy are:

- Cursive or script style, in which the letters are connected to one another
- Thin upstrokes, and thick downstrokes (pulling the pen towards your body), which you can create by applying more pressure on a flexible tip or adding additional lines

Firmer media are easier for beginners because they are easier to control. I recommend learning faux calligraphy first with pens you already own. You'll learn script styles using materials you're familiar with, and you won't need to invest in new supplies. However, if you're looking for the effect only created by certain supplies, such as the blended look of watercolor paints, feel free to jump in with any medium you want.

Practice Makes Perfect

You can learn a style by tracing or imitating a script font; font websites and calligraphy blogs make great reference resources. No matter which style you go for, frequent practice is key. Learning calligraphy takes time and effort, so don't give up too soon! Your first attempts will be the hardest steps in training your fine motor skills. Like your larger muscles when you work out, the muscles in your hands need training to write smoothly and apply pressure evenly. Once you've got those skills in the bag, mastering new calligraphy styles or creating your own will be a breeze.

LETTERING FOR TITLES

• • • This section includes ideas for lettering titles and headers in your bullet journal, along with some short descriptions of how to achieve these effects. All of the following examples are greetings from across the world.

①

1. Use a black pen to write in cursive and add an extra line on each downstroke. Color in the downstroke with a marker.

Hello: *Swedish*

②

2. Draw a banner and write with a black pen. Color the shadows of the banner with a marker.

Hello: *Igbo*

③ NAMASTE

3. Use a highlighter or marker to write in thick block letters. Add a drop shadow with a brush pen or thick marker and then trace all other edges with a thin black pen.

Hello: *Hindi*

Hand lettering on this spread and on pages 100–103 by Jasmine.

④

4. With a black pen, write in cursive, connecting the letters to a line on each side.

Hello: *Finnish*

⑤

5. Create block letters using a brush pen or marker. Then, use a black pen to draw the outline of block letters shifted slightly upwards and toward the left.

Hello: *English*

6. Use a black pen to write your title, draw a paper airplane, and add a loopy dotted line as the trail. Color the shadows of the paper airplane with a marker.

Hello: *Turkish*

⑥

⑦

7. Write the title in letters at an even height and then add lines on the top and bottom.

Hello: *Hungarian*

8. Draw a black oval with a pen or marker and then add a drop shadow with a black pen. Write the title in a white pen.

Hello: *Mandarian*

⑧

9, 10, 11. These three titles start by lettering your title with a brush pen. Then, add textures and designs with a white pen.

Hello: *Italian*
Hello: *Hebrew*
Hello: *Maltese*

12. Letter the title using a brush pen. Add a drop shadow with a thick black marker or brush pen and trace the remaining edges with a thin black pen.

Hello: *Luxembourgish*

13. Create block letters with a marker and black pen. Optionally, you can leave a white highlight on each letter to create a glossy effect. Then, use a black pen to add vertical lines, creating the ornament look.

Hello: *Swahili*

(14)

14. Draw a banner, with a pennant for each letter.

Hello: *Polish*

(15)

15. Create block letter outlines with a black pen. Use a marker or brush pen to color the bottom two-thirds of each block letter.

Hello: *Slovak*

(16)

16. Write your title in a black pen and then draw a rectangle around it. Add a drop shadow with a colored marker and then trace the drop shadow with a black pen.

Good Morning: *Croatian*

(17)

17. Use a black pen to write the title and draw a banner.

Hello: *Indonesian*

(18)

18. Write in cursive with a black pen and then add three lines on each end using a colored marker.

Hello: *Serbian*

(19) *konnichiwa*

19. Write the title with a black brush pen. Add a drop shadow with a colored pen or marker.

Hello: *Japanese*

(20) GUTEN TAG

20. Use a black pen to add curved leaf doodles on each side of the title.

Hello: *German*

(21) OLÁ

21. Imitate a serif font, which is a font with smaller lines at the ends of main strokes, and add designs inside the thicker strokes with a black pen.

Hello: *Portuguese*

(22) bună ziua

22. Write with a brush pen or marker and draw a bubble around the entire shape with a black pen.

Hello: *Romanian*

(23) HAFA ADAI

23. Make a background scribble with a brush pen or marker, then write over it with a black pen.

Hello: *Chamorro*

(24) ZDRAVSTVUYTE

(25)
GOD DAG

(26) HOLA

(27) D'A DHUIT

(28) BONJOUR!

24. With a black pen, add a long horizontal vine doodle underlining the title.

Hello: *Russian*

25. Draw this banner design and write the title with a black pen and then color the shadows with a marker.

Hello: *Danish*

26. Write in large letters using a brush pen or marker. Then, use a black pen to write in cursive on top of those letters.

Hello: *Spanish*

27. Use a marker to write your title, shifting up and down for each letter. Use a black pen to trace the letters.

Hello: *Gaeilge*

28. With a marker or colored pen, add squiggly lines above and below the title.

Hello: *French*

DOODLES

● ● ● There are many ways to incorporate doodles into your bullet journal! I don't recommend doodling while taking notes in class, but it can be fun to go back in afterwards and add in doodles relating to the notes. This helps me, as I am a visual learner and small symbols remind me of what I learned. That said, your doodles don't always need to serve a particular purpose; they can be mindless patterns to provide stress relief, among other things.

I love doodling when planning because it allows me to be creative. Sometimes, I am only able to do the bare minimum and just have time to throw in a splash of color with a highlighter, but I always try my best to allow myself to do some sort of small doodle.

Symbols
When writing notes, it is fun to add small symbols to help you remember the content. These should be simplistic and quick to add in. For example, when writing about Shakespeare's life, with each fact about him I add a symbol: For the plays he wrote, I draw a little quill. For his family life, I draw a heart. For the time period, I draw a clock with the date written below. This can also help me to remember important facts, such as the date I drew under the clock.

Banners
If I want to emphasize a heading, I will draw a banner around it. There are many different ways to do this, and I encourage you to find your own style, but here are some examples.

Flourishes
Similar to banners, you can add flourishes to the sides of headings to help them stand out in your notes.

Bullet Points
Plain bullet points are quick and easy, but sometimes I like to use fun shapes to switch things up. See the examples at right for inspiration.

Accents
I like to add accent pieces, especially on my planning spreads where I have more time to dedicate to the piece. These can vary from simple to complex. For me, there is something very relaxing and freeing about creating this free-form piece of work. For some people, this can seem stressful until you practice and develop a few techniques for doodling that you enjoy. Doodling can really unleash your artistic side and provide a creative outlet.

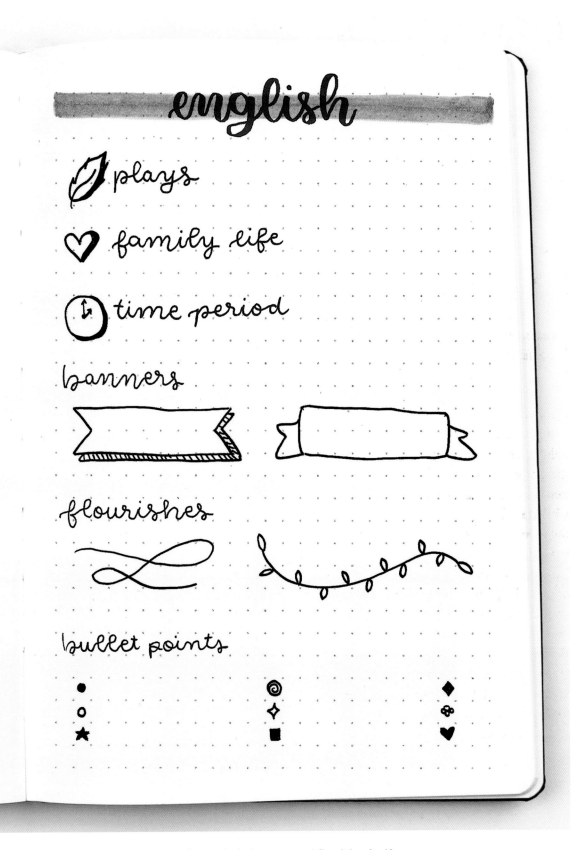

english

- ✒ plays
- ♥ family life
- 🕐 time period

banners

flourishes

bullet points

Some fun symbols, banners, and flourishes by Alyssa that can be integrated into notes for emphasis as well as meaning.

CREATING & INCORPORATING ARTWORK

● ● ● There are many ways you can incorporate your artwork into your bullet journal. The main place I do this is on my monthly cover pages. If you enjoy creating artwork, I recommend cutting watercolor paper, or whatever material you use to create your artwork, to the size of a page and then creating your artwork and gluing it into your book to avoid bleeding through pages. Alternatively, if you also want to use your artwork for another project, you can scan it and resize the image to fit on your page and then print that and paste the picture into your bullet journal. Below or above the artwork, I typically hand-letter the month and add in a small calendar. Depending on the size of your artwork, you could also include a quote.

Additionally, "artwork" doesn't necessarily mean drawing or painting. You can take photos and include a collage that matches a specific color scheme, or add photos that inspire you, of your friends and family, or of activities that you are involved with at school or outside of school. Photos are easy to stick in with some double-sided tape. I also like to add in washi tape and draw flourishes onto the photos with a black or white pen, depending on the colors of the photos.

You could also combine your artwork and collage if you so choose. You could do any combination of drawn or painted artwork, collages, quotes, and doodles. See page 104 for more details on doodling.

You could add in craft paper and write on it with white pen—that usually looks quite striking. You could rub a wet tea bag on plain paper to create the effect of old, crumpled paper and then paste that in your book for a multimedia effect. There are endless possibilities when it comes to creating and incorporating your artwork.

Two sample openers for monthly layouts by Alyssa that incorporate hand painted and hand drawn artwork. Artwork by Cierra Jagan.

RESOURCES

Bullet journaling guidance

www.bohoberry.com
www.bulletjournal.com
Carroll, Ryder. *The Bullet Journal Method.* New York: Portfolio/Penguin, 2018.

Calligraphy & art tutorials

www.piscescalligraphy.com
www.thepostmansknock.com
www.youtube.com/user/amandarachlee

Stationery guides

www.jetpens.com/blog
www.thepenaddict.com

Studying & Productivity

www.collegeinfogeek.com
Duckworth, Angela. *Grit.* New York: Scribner, 2018.
Duhigg, Charles. *The Power of Habit.* New York: Random House, 2012.
Rubin, Gretchen. *Better Than Before.* New York: Crown Publishers, 2015
Wyner, Gabriel. *Fluent Forever.* New York: Harmony Books, 2014.

ACKNOWLEDGMENTS

Thank you, 谢谢, et merci to all of my teachers:

The team at Quarto—Joy, Marissa, Hannah, Nyle, Madeleine, and everyone else I haven't met. This book wouldn't be possible without your skill and experience. Special thanks to Alyssa, for her can-do attitude and bright ideas. I appreciate all of your patience with this occasionally-scatter-brained first-time author.

My parents, for trusting me enough to allow me to "waste time" on the Internet and hide in my closet to record voiceovers. For feeding me dumplings when I'm simultaneously editing and doing homework at an ungodly hour. For being my #1 and #2 fans since September 10, 2016.

Anyone who has instructed me in a classroom, for creating challenges that teach me how to teach myself. A special shout-out to Ms. Montgomery, for helping me redefine success and happiness, and a few particular history and English teachers who have given me confidence in my writing abilities.

Coach Rudy, for your unrelenting encouragement and fearless determination to wear three jackets and dress pants in 100-degree weather.

My marvelous, stellar, wonderful, incredible, extraordinary, and fabulous friends. I checked thesaurus.com and there aren't enough good words to describe y'all.

Thank you for all you've taught me!

Without these wonderful people, this book wouldn't be as amazing as it is. Thank you to

- ♥ My teachers and mentors, specifically Ms. Phillips for teaching me how to write.
- ♥ The kind, creative online community that constantly inspires me.
- ♥ The entire Quarto team that made this book a reality.
- ♥ Joy Aquilino, my editor. Your patience and dedication never goes unnoticed.
- ♥ My family—Dad, Nanee, Nana, and Cierra.
- ♥ And, thank you Mom for your constant support and love.

ABOUT THE AUTHORS

JASMINE SHAO

Jasmine Shao, also known as **@studyquill**, is a high school student who shares videos and photos about studying, note-taking and calligraphy. She has gained over 450,000 subscribers on YouTube and 270,000 followers on Instagram, and has been featured in the *Wall Street Journal*, the *Sydney Morning Herald*, and *Good Housekeeping* magazine. She lives in San Jose, California.

ALYSSA JAGAN

Alyssa Jagan is Alyssa of **@CraftySlimeCreator**, which has been named one of the best slime accounts on Instagram. She is also the author of *Ultimate Slime*, which has been published in eleven languages, and the co-author of *Study with Me*, on how to use bullet journaling and time management techniques for successful studying, both published by Quarry Books. An 18-year-old college student and Toronto native, the popular Instagram slimer posts videos to her accounts every day, co-hosts the Slimey Sundays live podcast on Instagram with Erin Murphy of @SlimeonadeStand, and sells her products on her Etsy site, craftedbyalyssaj. In addition, Alyssa has been profiled by a variety of media outlets, including *The New York Times*, Associated Press, *The Globe and Mail*, and the BBC.

INDEX